# GREAT PUBLIC
# BUILDINGS
## OF THE
# NORTH EAST

## MICHAEL JOHNSON

AMBERLEY

First published 2024

Amberley Publishing, The Hill, Stroud
Gloucestershire GL5 4EP

www.amberley-books.com

Copyright © Michael Johnson, 2024

The right of Michael Johnson to be identified as the Author of this work has been asserted in
accordance with the Copyrights, Designs and Patents Act 1988.

British Library Cataloguing in Publication Data.
A catalogue record for this book is available from the British Library.

ISBN 978 1 3981 1198 1 (print)
ISBN 978 1 3981 1199 8 (ebook)

Typesetting by SJmagic DESIGN SERVICES, India.
Printed in Great Britain.

# Contents

# Acknowledgements

The author and publisher would like to thank the following people and organisations for permission to use copyright material in this book: Richard Arculus, Philip Barnes, Richard Bryant, FaulknerBrowns Architects, Historic England Archive, Jim McMaster, Middlesbrough Council, Newcastle City Council, Peace Drone, Jim Scott, Sunderland Antiquarian Society and Billy Wilson. Every attempt has been made to seek permission for copyright material used in this book. However, if we have inadvertently used copyright material without permission/acknowledgement we apologise and we will make the necessary correction at the first opportunity.

# Introduction

Britain's towns and cities are dominated by great public buildings. Serving their communities in diverse ways, government offices, museums, libraries and schools embody the ideals of civilised society. Foremost among these buildings are the town halls that govern our great municipalities. Politically, town halls are literal centres of power, the democratic forums of civic administration. Architecturally, they are inherently symbolic, proclaiming the status, values and history of the towns and cities in which they stand.

This book examines the architecture of town halls and civic centres in North East England, asking how these buildings fulfil their dual function of enshrining power and expressing civic identity. For the purpose of this study, the North East is defined as the area corresponding to the historic counties of Northumberland and Durham and the Cleveland district of Yorkshire. This region has a distinctive identity, shaped by a history of Roman dominion, medieval conflict and industrial enterprise. Analysing the region's major town halls within a single volume, this book considers how the conurbations of North East England expressed themselves through the medium of civic architecture. In doing so, it aims to supplement Colin Cunningham's study *Victorian and Edwardian Town Halls* (1981), which, though excellent, examines only two of the region's town halls in detail.

The buildings are surveyed in chronological order, enabling us to trace key narratives simultaneously: the region's historical development, the evolution of architectural taste, and changing paradigms of local government. Perhaps unusually, the survey includes four buildings that have been demolished – the Victorian town halls of Newcastle and Sunderland, and the modern civic centres of Sunderland and Chester-le-Street. Although lost to posterity, these buildings were the power bases of their respective towns and deserve to be reinstated into the history of the region's civic architecture.

Among the first civic buildings were medieval guildhalls, an example of which survives at Durham, though much altered. These were succeeded by the 'town houses' of the eighteenth century, which signalled the growing importance of provincial towns and cities in the Georgian era. Typically located at the heads of marketplaces, these consisted of an arcaded market hall with meeting rooms above. This model is exemplified at towns such as South Shields and Yarm. Stylistically, these early examples reflected the Georgian taste for Italian Renaissance architecture. Another impulse was the grander baroque style most visible in the work of Sir John Vanbrugh (1664–1726), who designed the great

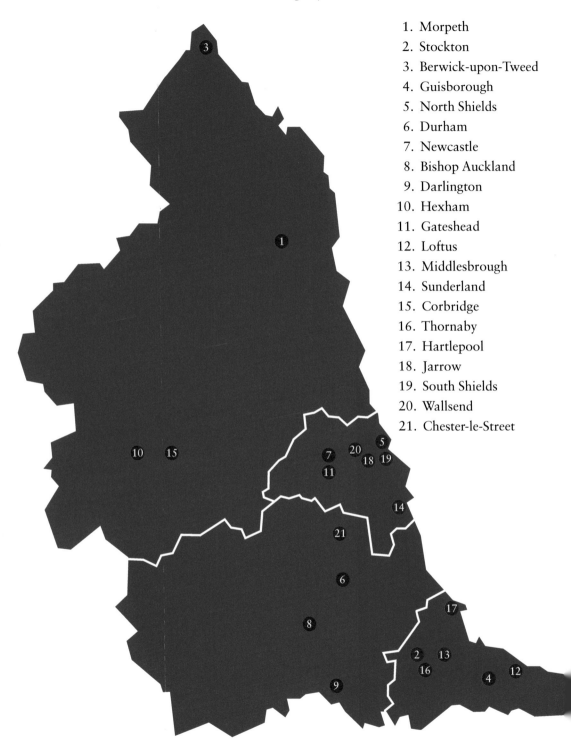

1. Morpeth
2. Stockton
3. Berwick-upon-Tweed
4. Guisborough
5. North Shields
6. Durham
7. Newcastle
8. Bishop Auckland
9. Darlington
10. Hexham
11. Gateshead
12. Loftus
13. Middlesbrough
14. Sunderland
15. Corbridge
16. Thornaby
17. Hartlepool
18. Jarrow
19. South Shields
20. Wallsend
21. Chester-le-Street

Map showing the location of towns and cities featured in this book. (AdobeStock_70997157)

northern houses of Castle Howard (1700–12) and Seaton Delaval (1720–28). The Northumberland market town of Morpeth is fortunate to possess a civic building by Vanbrugh himself, while Berwick-upon-Tweed's commanding town hall reflects his pervasive influence.

In the nineteenth century, industrialisation and urban expansion necessitated a new system of local government. The Municipal Reform Act of 1835 established 178 municipal corporations, each governed by an elected council. This growth in municipal bureaucracy demanded buildings for its administration and symbolic expression. Town halls became one of the most important building types of the nineteenth century. Each constituted a centralised base for the administration of its township, accommodating the council and various borough committees.

Town halls must be seen as products of the new urban consciousness emerging in this age of transformation and optimism. As one commentator noted:

> Nineteenth-century architecture will be written mainly, not in its great churches nor monuments, but in the record of its municipal and civic buildings. Its town-halls and city offices, its technical schools, and its libraries and museums, its public baths and wash houses will form the material of the future historian who undertakes to write the chronicle of its progress.[1]

A dignified civic building was essential for the prestige of any Victorian town, proclaiming its status, prosperity and values to citizens and rival towns. For example, as he laid the foundation stone of Hexham Town Hall, W. B. Beaumont MP declared 'It was a disgrace to this town – which we are assured on no mean authority will someday become the metropolis of Northumberland – I say it was a disgrace to the town of Hexham when the little town of Bellingham could boast of its Town Hall.'[2]

In terms of patronage, municipal and commercial bodies generally replaced the aristocratic patrons of the eighteenth century, although Loftus Town Hall, financed by the Earl of Zetland, was an exception. Many town halls were built by municipal corporations and funded by public subscription. Others, such as Bishop Auckland Town Hall, were built by public companies established specifically for that purpose, raising money by selling shares. Designs were generally obtained via architectural competition and commissions were decided by bureaucratic committees. Many town halls were designed by national or leading regional practitioners equipped with generous budgets, providing rich opportunities for architectural display.

Civic architecture was rarely innovative because it tended to rely on recognisable styles and symbols in order to communicate with its public. Within these limitations, however, North-East town halls kept pace with the national mainstream. The classical style of architecture was favoured for early Victorian town halls, evoking the ideal of Athenian democracy. By the 1860s, the influence of the Gothic Revival, so dominant in ecclesiastical architecture, had permeated

public buildings. The architecture of the late Victorian period reveals a desire to abandon the rigidities of the classical and Gothic styles, resulting in eclectic designs based on Italian and French Renaissance precedents. The turn of the century witnessed a revival of the exuberant baroque architecture of Vanbrugh. South Shields Town Hall exemplifies this Edwardian grand manner.

Ostensibly, town halls were expressions of representative government, visible symbols of democracy in action. However, they could not have been built without the proceeds of commerce. In many cases their construction was financed by powerful private citizens, typically the industrial magnates who became Britain's new ruling class in the nineteenth century. Municipal corporations were dominated by such individuals, who were often interconnected through family or business ties, effectively forming an oligarchic elite. Potent myths of their enterprise and benevolence were woven into the fabric of town halls by means of statuary, commemorative inscriptions and stained glass. With this splendid scenography, Victorian and Edwardian town halls were theatres of capitalism. Allegorical representations of industry, commerce and the arts functioned in hegemonic terms, presenting the values of the elite as the common-sense values of all, the basis of a benevolent social order.

In the twentieth century, post-war ideals of democracy engendered a new conception of local government. Combined with the radical doctrines of modernist architecture, this produced a spate of 'civic centres' conceived as beacons of modernity and political transparency, at Newcastle, Sunderland, Darlington and Chester-le-Street. However, these more abstract buildings sometimes struggled to communicate with the public, becoming inadvertent symbols of faceless bureaucracy.

Of the region's civic buildings, some continue to serve as seats of local government, but others have been adapted for new functions. Many have been refurbished internally, making it necessary to reconstitute their original designs from archival sources before a vital part of their heritage is forgotten. Whether forums of democracy or bastions of civic power, these buildings, beautiful, bombastic or impersonal, represent the symbolic heart of the region's urban communities.

## Morpeth Town Hall

The county town of Northumberland, Morpeth stands on the River Wansbeck 15 miles north of Newcastle. Its name possibly derives from 'moor path', referring to its historic location on the Great North Road from London to Edinburgh. Morpeth's importance as a river crossing led to the construction of a Norman castle by 1095. King John granted permission for the town to hold a market in 1199, and by the mid-eighteenth century it had become one of the most important cattle markets in the country.

Recognising Morpeth's growing status, Charles Howard, the 3rd Earl of Carlisle, erected an imposing town hall in the market square in 1714. This was designed by the renowned architect Sir John Vanbrugh, a leader of the English baroque school. Vanbrugh's association with the earl began in 1699, when the latter commissioned him to design Castle Howard in Yorkshire, one of England's greatest baroque houses.

Emerging towards the end of the Renaissance, the baroque style was based on the permutation of classical architecture, distorting its idealised forms to produce effects of grandiosity, movement and spatial complexity. Vanbrugh's work typically explores the dramatic possibilities of scale and mass. His buildings juxtapose central blocks and flanking towers, animated by patterns of advance and recession. Stripped of the classical orders, they communicate through superhuman proportions and bold, theatrical massing, many having what Vanbrugh called a 'castle air'. This cyclopean architecture seemed perfectly attuned to the rugged landscapes of Northumberland.

Morpeth Town Hall appears to be Vanbrugh's first work in the region, preceding his design for Seaton Delaval and his remodelling of Lumley Castle (1722). Following the basic configuration of his country houses, the dominant

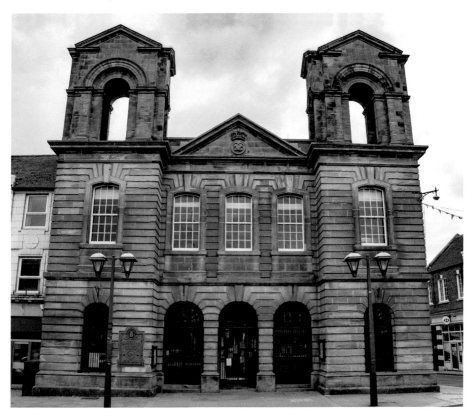

Morpeth Town Hall. (Image © Jim McMaster)

central block is framed by corner towers, producing a dramatic silhouette. In scale and proportion, however, the building is more akin to Vanbrugh's smaller garden structures, such as the belvedere at Claremont (1715) or the summer house at Grimsthorpe Castle (1720).

The detailing of the towers anticipates Vanbrugh's first design for Eastbury, a country house in Dorset (*c.* 1715). In both cases, the towers are rectangular rather than square in plan and terminate with massive upper stages pierced by arches and crowned with open pediments.[3] Eastbury was built to a revised design in 1718–38, with modified towers, making those at Morpeth a fascinating record of the development of Vanbrugh's architectural language in this period.[4] In their overall form, the towers resemble sentry boxes, revealing Vanbrugh's nostalgia, as a former soldier, for military fortifications.

The entire façade is clad in banded masonry, breaking into voussoirs around the arched openings. This is a form of 'rustication', a term referring to various ways of shaping stone blocks to evoke the rugged quality of hypothetical rustic buildings. Between the towers is a steeply pitched pediment, typical of the baroque distortion of classical forms.

Vanbrugh's building was apparently destroyed by fire in the 1860s and rebuilt in 1868–70 by the talented Newcastle architect Robert James Johnson (1832–92).[5] Born in Stokesley, Johnson trained in Darlington before joining the office of the renowned architect Sir George Gilbert Scott. With Thomas Austin (1822–67), he purchased the Newcastle practice of John Dobson (1787–1865) on the latter's death and this may explain how Johnson received the commission for Morpeth Town Hall, since Dobson would have been the optimal choice for this work.

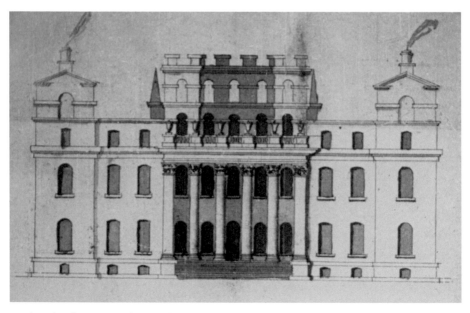

Vanbrugh's first design for Eastbury in Dorset.

Like Dobson before him, Johnson became the leading architect in the North East. As an antiquarian, he was usually sensitive in his restoration work and his façade for Morpeth Town Hall was said to be an exact facsimile of the original.[6] The restoration was assisted by Benjamin Ferrey's precise drawings of the town hall, made when he came to Morpeth to design St James' Church in the 1840s. The rear portion of the building was entirely rebuilt in brick, but Johnson designed the interiors in an early eighteenth-century style to complement the façade.

The ground floor was largely occupied by a corn exchange and theatre. Wrought-iron grilles were installed within the entrance arches to enhance security. The first floor retains a large panelled room that served as a courthouse, guildhall and public ballroom. Its grand fireplace was built in Caen stone, with an elaborate wooden mantelpiece displaying armorial emblems of the Earls of Carlisle. Johnson also introduced a council chamber, mayor's parlour and a library and reading room for Morpeth Mechanics' Institute.

The contractor for the rebuilding was Robert King of Morpeth, who constructed many of the town's Victorian buildings. Another local man, Joseph White, was responsible for the carpentry, while the roof slating was provided by Preston of Sunderland.[7] The internal plastering was by H. Brown of Berwick. J. T. King of Morpeth supplied the plumbing and ironwork. A new heating apparatus was introduced by the well-known Newcastle firm of Walker & Emley. Finally, the painting and glazing were by Bowman & Sons of Morpeth.

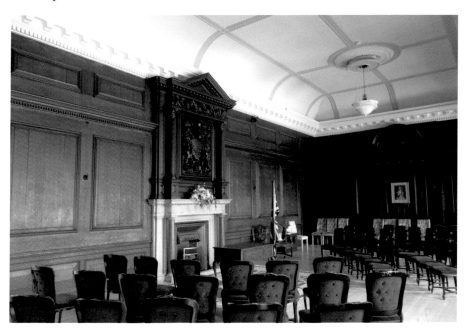

Courthouse, guildhall and ballroom.

The enlarged town hall was built at a cost of £10,000 by the 8th Earl of Carlisle, who infused it with signs of aristocratic power. Charles Howard's monogram was incorporated into the pediment during rebuilding, the interlocking letter Cs denoting 'Carolos Carliolensis'. A portrait bust of the 7th Earl of Carlisle was installed in a niche above the staircase, executed in Carrara marble by the great Irish sculptor John Henry Foley (1818–74), whose best-known works are the statues of Daniel O'Connell in Dublin and Prince Albert at London's Albert Memorial. The *Morpeth Herald* welcomed the new town hall as 'a building which all will acknowledge was much required in the town', and hoped that 'the purposes for which it will in future be used will tend to the moral and intellectual improvement of the inhabitants'.[8] Today, the building provides accommodation for Morpeth Town Council.

## Stockton Town Hall

Stockton originated as an Anglo-Saxon settlement on elevated ground north of the River Tees. Formally known as Stockton-on-Tees, the town developed into a busy port in the Middle Ages. The Bishop of Durham authorised a market in 1310 and the presence of the market square shaped Stockton's urban form, which boasts the widest high street in England. By the eighteenth century, Stockton was a flourishing port and commercial centre. It earned a place in history when the world's first public railway opened between Stockton and Darlington in 1825, launching a new age of industry, trade and travel.

At the centre of Stockton's unique high street stands its historic town hall. The first structure on the site was a 'town house' completed around 1100. Described as 'a mean thatched cottage',[9] this was abandoned in the late seventeenth century and a new tollbooth was erected immediately to the south, serving as an administrative base and residence for the mayor.

The Georgian era brought prosperity and the present building was erected in 1735. Despite its larger scale, it exemplifies the town houses of the eighteenth century, which were generally four-square edifices with arcaded ground floors and hipped roofs surmounted by cupolas. The early town halls at Yarm (1710) and South Shields (1768) follow the same typology.

As Stockton was deficient in good building stone, most of its buildings were constructed in brick, a material that was widely available by the late seventeenth century. Exemplifying this tradition, the town hall is composed of plain brick and crowned by a roof of red pantiles. Facing the market square, the main entrance is a round-headed arch framed by engaged columns of the Doric order. Above is a bold representation of Stockton's coat of arms; castle and anchor motifs allude to Stockton's medieval castle and the town's status as a port. The building was originally open at the base, with shops occupying the arcades. The most elegant aspect is the symmetrical north elevation, where Renaissance-style windows

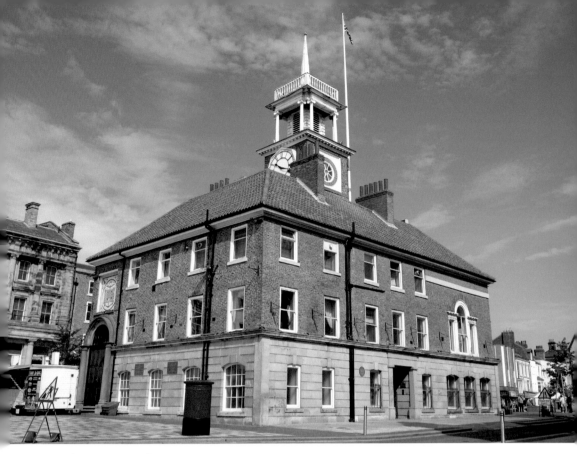

Stockton Town Hall.

illuminate the main council rooms within. The present council chamber was created when the building was renovated in the 1880s. The seating was arranged in a semi-circular pattern, as recommended by Victorian experts in town hall design.[10]

The present roof and its charming wooden clock tower date from 1744, when the adjacent tollbooth was demolished, allowing the town hall to be extended. The clock tower houses a bell that was used to signal the opening and closing of trade within the market. A piazza was added to the building's north face in 1768–69 by Ralph Stubbs. This was covered with a cast-iron canopy in 1890, but this was sacrificed to the war effort in 1940, when iron was in high demand. The ashlar cladding around the basement was introduced when the building was restored in 1985.

It was in the town hall that Leonard Raisbeck, recorder of Stockton, first proposed the construction of a railway from the South Durham coalfield to Stockton in 1810. The town hall lost its civic function when the county borough of Teesside was established in 1968, but its status was restored when Stockton-on-Tees Borough Council was formed in 1974. Weathering all these changes, the building remains one of the oldest town halls in the country still used for its original purpose.

Berwick Town Hall

The northernmost town in England, Berwick stands near the mouth of the River Tweed in the long-contested border region. A lynchpin in the conflicts between England and Scotland, the town changed hands fourteen times in the Middle Ages, finally coming into the possession of the English Crown in 1482. Berwick became a parliamentary borough, but because it lay outside all existing counties, it enjoyed a remarkable degree of self-government. The town retained its military importance, as the impressive walls and garrison testify. Protected by these fortifications, Berwick prospered thanks to a flourishing cloth industry and the export of wool to Flanders. Today, it remains Northumberland's finest Georgian country town.

The local seat of government was a building called the tollbooth. By 1749, this structure was showing signs of decay and a guild committee was formed to procure a new 'Tollbooth, steeple and proper gaol.'[11] A building fund was raised from fines and taxes. The guild invited local master-carpenters to submit designs for the new building, eventually selecting one by Joseph Dodds. Born in 1716, Dodds was apprenticed to his father as a carpenter and builder before establishing himself as a builder and brickmaker. As he had no experience of undertaking such a project, the guild sent his plans to architects in London and Edinburgh for 'approbation and correction.'[12] One of the firms consulted was that of Samuel and John Worrall of London, who subsequently submitted plans of their own, consisting of two elevations and one section. Their design bore a clear resemblance to James Gibbs' metropolitan church of St Martin-in-the-Fields (1722–26), a highly influential building due to its unconventional juxtaposition of a classical temple portico and a soaring spire.

The building's authorship has been debated, but it seems that Dodds incorporated the Worralls' revisions into his own design, including the portico.[13] He produced a wooden model to convey his proposals and was rewarded with a commission to complete the building within a three-year period. The words 'Joseph Dods. archt.' are inscribed behind the portico, indicating that he was eager to be seen as sole architect. Nevertheless, Dodds was aided by his clerk of works, Francis Gatton, who had often advised the guild on repairs to the town's bridge and quay.

The design was modified during construction, probably at Gatton's suggestion. In the week following his appointment it was decided to build a single broad flight of steps at the front, rather than two, and to erect a 'piazza' at the rear. The guildhall was enlarged at the expense of the entrance lobby and a window was added to the north side, thus creating a larger and brighter space for public assemblies. Incorporating all these revisions, the town hall was built in 1754–61. Dodds was ordered to recover the bells, clock and anything else worth saving from the old tollbooth. The bells were sent to London and recast at a cost of £300, before being installed in the building, along with a new clock.

Public buildings in Northumberland are generally small, but Berwick Town Hall signalled greater ambition as the town and county grew in civility. The completed building forms a dramatic focal point at the head of Marygate, rising from a commanding site. A steep flight of steps sweeps up to an impressive tetrastyle portico with giant columns of the Tuscan order. This type of temple portico was a popular element in the 1710s and 20s. The monumental pediment features a superb representation of the borough's coat of arms. Soaring above the portico, the tower is clearly derived from Gibbs' aforementioned church, plans for which were published in his *Book of Architecture* (1728).

The façades are executed in pink-tinged local sandstone, with quoins and rustication echoing the rugged spirit of Vanbrugh. The south elevation has an arcaded ground floor that originally housed shops. At the east end is the open piazza, which was used as a butter market.

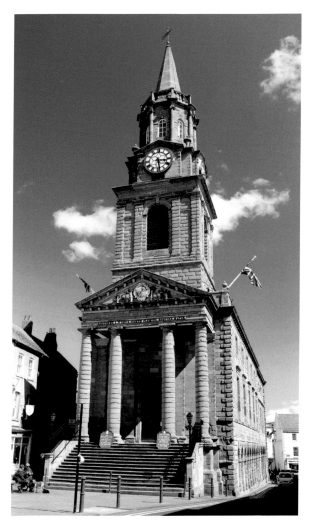

Berwick Town Hall.
(Image © Richard Arculus)

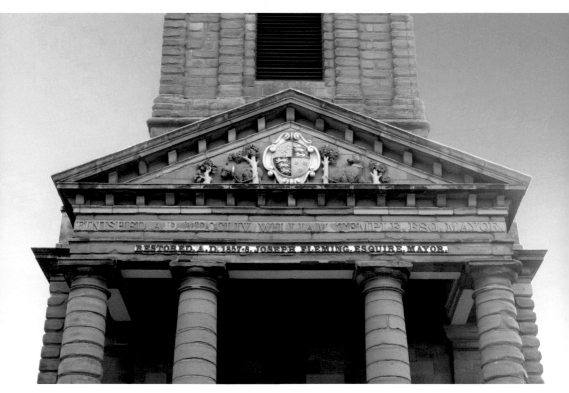

*Above*: Berwick's coat of arms within the pediment.

*Below*: Council chamber, with a sculptural representation of Justice.

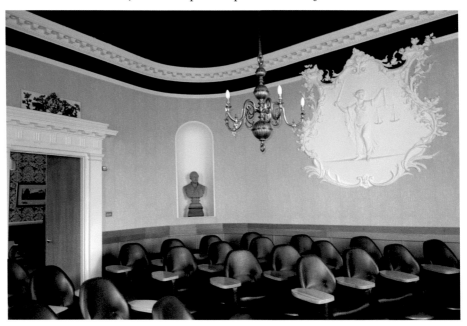

Internally, the principal room was the guildhall on the first floor. A council chamber lay beyond, lit by an elegant Venetian window. The present furnishings date from the local government reforms of 1974, but a fine plaster relief of Justice survives, set within a rococo cartouche. This was made by the local artist Joseph Alexander in 1789. The mayor's parlour lies at the north-east corner. Prison cells occupied the top floor, still identifiable from the iron grates over the windows and vivid graffiti inscribed on the walls. The roof was used as an exercise yard for prisoners, politely screened by high parapets.

Berwick Borough Council considered demolishing the town hall after the Second World War, but this fine public building was saved by a campaign led by Sir Albert Richardson, President of the Royal Academy of Arts, who had great affection for Berwick. The building survives as a baroque gem and testifies to Vanbrugh's influence in Northumberland.

## Guisborough Town Hall

The ancient market town of Guisborough lies on the edge of the North Yorkshire Moors. It became a place of pilgrimage when Robert de Brus founded an Augustinian priory here in 1119. After the Dissolution of the Monasteries, the priory was sold to Sir Thomas Chaloner in 1550, and his family became the principal landowners in the district. The Chaloners established Britain's first alum works at Guisborough, producing a chemical vital for the textile industry. The town subsequently shared in the prosperity of the Industrial Revolution thanks to its proximity to the ironstone mines of Teesside.

A town hall was built in 1821 to house the manorial court, Guisborough's governing body until the formation of the town council. Erected on the site of an ancient tollbooth, this is an austere structure, powerfully built of sandstone, and typical of the classical town halls of the early nineteenth century. Reputedly, some of the stone came from nearby Tocketts Hall, a Chaloner mansion that was demolished in the same year. Significantly, the town hall was built as a two-storey structure, with a courtroom, prison cell and butchers' market on the ground floor. An additional floor was constructed in 1870. According to a contemporary newspaper report, the town hall was 'enlarged and raised, a storey being added to it.'[14] However, refurbishment work in 2021–22 revealed that the new floor was actually suspended from the roof and the entire building was given a new external skin of Aislaby sandstone. The external detailing dates from this period, though it resembles a robust, early nineteenth-century interpretation of classical architecture.

Each face is articulated with giant pilasters and horizontal stringcourses. The stark façades are surmounted by simple triangular pediments. A cartouche bearing the arms of the Chaloner family is displayed on the principal pediment. According to a press report from 1870, this was executed in Caen stone and was salvaged from the ruins of Guisborough Priory, where it was found to be 'in a most wonderful

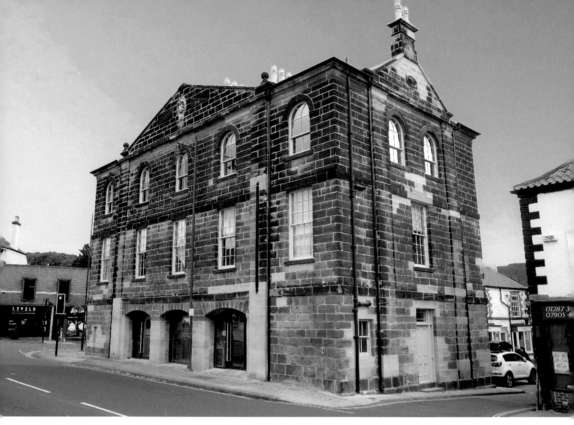

Guisborough Town Hall.

state of preservation, not a single line of the carving being obliterated with age.'[15] Based on its design, however, the cartouche appears to date from the eighteenth century. The new floor was lit by round-headed windows, reflecting the Italianate taste of the era. Following these alterations, the *Newcastle Chronicle* declared 'This building is now perhaps one of the finest town halls in the North Riding.'[16]

The three-storey building had offices on the ground floor, with a justice room and magistrates' clerk's office on the first floor, and offices for the Board of Health, savings bank and Highway Board on the second. The justice room was chosen as a county court for the eastern portion of Cleveland.[17] The barred window of the adjoining prison cell is still visible at the rear.

The building has had many roles throughout its history, but eventually fell into disuse. The Guisborough Town Hall Gateway Project was launched in 2016 to transform the building into a visitor centre, aided by the Heritage Lottery Fund. Conservation specialists Beaumont Brown Architects supervised the regeneration and the building work was conducted by Hall Construction.

## Tynemouth Town Hall

Tynemouth Town Hall is a complex building with a convoluted history, exemplified by the fact that it stands not in Tynemouth but in North Shields. The reason

for this anomaly lies in the administrative history of these neighbouring towns north of the Tyne. The building was erected in 1844–45 as municipal offices for the Improvement Commissioners of North Shields. After significant population growth, this town was absorbed into the borough of Tynemouth in 1849, and the newly formed Tynemouth Borough Council adopted the building as its town hall.

Established in 1828, the North Shields Improvement Commissioners determined to erect premises for the administration of the town, which was growing in prosperity due to the fishing industry and a burgeoning tourist trade. A site on the corner of Howard Street and Saville Street was selected and the building was financed by Joseph Laing, a solicitor and bank agent.

The new offices were constructed around an existing building for the Poor Law Guardians that stood at the south-west corner of the site. Erected in 1837 to designs by John (1787–1852) and Benjamin Green (1813–58), this building can still be identified by its curved, Jacobean-style gables. The new building was designed by the region's leading architect John Dobson, who was born near North Shields. Though primarily a neoclassicist, Dobson produced an informal Tudor-Gothic design. Certainly, he was a competent exponent of this more adaptable mode, using it for domestic works such as Cheeseburn Grange, Northumberland (*c.* 1813) and Benwell Towers, Newcastle (1831). A number of Tudor-Gothic town halls were built throughout Britain in the 1840s, consciously evoking the legacy of medieval guildhalls. Together, they constitute an important phase in the development of civic architecture, paving the way for the High Gothic town halls of the 1860s.

Dobson's building consists of two castellated blocks, with powerful gables at the extremities to anchor the composition. Tall octagonal chimneys enliven the gables. The material is sandstone ashlar, in contrast to the coarse, 'snecked'

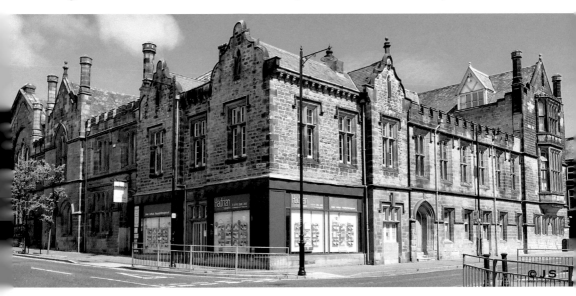

Tynemouth Town Hall. (Image © Jim Scott)

stonework of the Poor Law building, whose shaped gables contrast with Dobson's battlemented ranges.

The interior was described as 'handsome and well adapted to its purpose.'[18] Indeed, the building was intended to fulfil many functions, incorporating offices for the Improvement Commissioners and the Borough Treasurer's department, as well as a magistrate's court, savings bank, mechanics' institute, museum and police station. Like all town halls, the building also had a symbolic function, forming a 'repository for works of art and portraits of eminent persons.'[19] A subscription was established to raise funds for placing a portrait of Queen Victoria in the courtroom and a bust of the benefactor, Joseph Laing, was commissioned by his friends after his death in June 1847.[20]

Seeking more accommodation, the council acquired the Poor Law building, as well as an adjacent Wesleyan Methodist church (1856) by Dobson. The building continued to serve as offices for the Borough Treasurer but lost its civic function after North Tyneside Council was formed in 1974. Currently known as the Exchange, the building is used as a theatre.

## Durham Town Hall

The cathedral city of Durham stands on a peninsula formed by the River Wear as it meanders through the historic County Palatine. Its name is derived from the Brythonic 'dun', meaning 'hill', and the Old Norse 'holm', meaning 'island'. According to legend, the city was founded in AD 995, when monks from Lindisfarne chose the high, wooded peninsula as the final resting place of St Cuthbert.

As Durham became an important place of pilgrimage, Bishop Aldhun built a stone church on the site of Cuthbert's shrine in AD 998. This modest church was supplanted by the majestic Norman cathedral that crowns the peninsula today. Durham played an important defensive role in the conflicts between England and Scotland and its castle is the only Norman keep that has never been breached. The Prince Bishops of Durham were granted extraordinary powers by William the Conqueror. As long as they were loyal to the Crown, the County Palatine of Durham was theirs to rule.

Durham Town Hall stands on the west side of the historic marketplace, merging with an ancient complex of buildings. The city's first seat of civic administration was a guildhall erected on this site in 1356 as a meeting place for merchant guilds. This timber structure was rebuilt in stone by Bishop Cuthbert Tunstall in 1535, and again by Bishop John Cosin in 1665, following a disastrous invasion by Scottish forces. Cosin's guildhall is the oldest part of the current building.

By the nineteenth century, the guildhall had become too small to function and the mayor, William Henderson, proposed a new building. The building committee examined several town halls and concluded that Philip Charles Hardwick's design

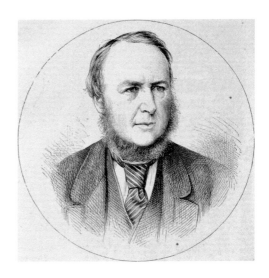

Portrait of P. C. Hardwick.

for Lincoln's Inn Hall (1845) in London demonstrated that he 'possessed talents of a higher order than was required for any work they could hope to accomplish in this city.'[21] Born in Westminster, Hardwick (1822–92) was the son of Philip Hardwick (1792–1870), architect of London's Euston Arch. He trained with his father and became a leading architect of grand banking offices in the City of London, as well as architect to the Bank of England.

Hardwick visited Durham and stayed three days, making 'a most careful examination of the ground.'[22] He produced an extensive report outlining how he proposed to integrate his design with the existing buildings. Hardwick envisioned a town hall in the Perpendicular Gothic style that flourished from the late fourteenth to the early sixteenth century. This was the final phase of English medieval Gothic architecture, characterised by the vertical thrust of its window tracery. As a city dominated by its medieval citadel, it was fitting that Durham's town hall should be designed in a Gothic style. Built to the west of the guildhall in 1849–53, the building replaced a medieval house that once belonged to the Earls of Westmoreland. Dignitaries of the city contributed to the building fund, including the Bishop of Durham.[23]

The façade is simple and planar, pierced by strong arches. The result is convincingly medieval. To achieve this effect, it was necessary to remodel Bishop Cosin's guildhall, which had been given a Palladian-style façade by John Bell in 1754. Hardwick Gothicised this façade, introducing a large window with Perpendicular tracery and a wooden flèche to replace the Italianate cupola. Forming the centrepiece of the new frontage, the guildhall terminates with a crenelated parapet and a pointed gable. An ornate cast-iron balcony was provided for electioneering, supported on massive stone brackets. Covered markets were built beneath the town hall in 1851–52.[24]

The building was conceived as a 'means of transmitting to posterity the history of those who have borne names eminent for service done in the city or county in

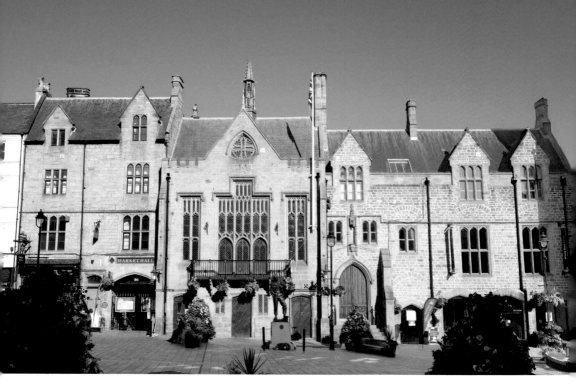

*Above*: Durham Town Hall.

*Left*: Durham Guildhall, showing John Bell's Palladian façade (above) and as remodelled by P. C. Hardwick (below). (Image © Martin Roberts)

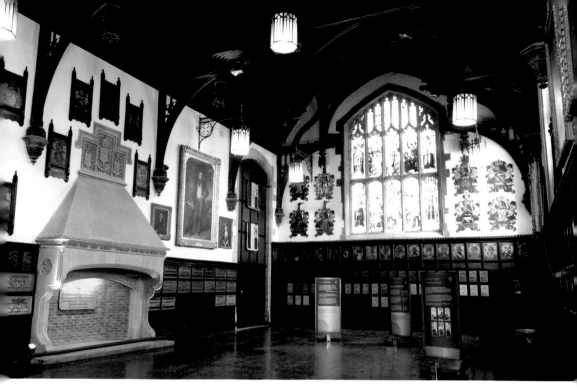

Durham's great hall.

times past and present.'[25] The principal room is the great hall, which was built at a cost of £3,028, raised by public subscription. Designed in a fourteenth-century style, the hall has richly panelled walls, a grand fireplace of Prudham stone and a brilliantly carved hammerbeam roof in oak. This was based on the medieval roof of Westminster Hall. Angelic figures brandish the crests of Durham's historic guilds and painted panels commemorate those awarded the honorary freedom of the city.

The great west window by Ward & Nixon of London (1851–53) illustrates the balance of religious and temporal power in Durham. Glorious illuminated panels depict four Prince Bishops who granted charters to the city, as well as the annual feast of Corpus Christi, when guild members would carry banners in a procession from the guildhall to the cathedral. The final scene shows King Edward III distributing gold coins in the marketplace as a gesture of thanks to Durham for recapturing property he had lost to the Scots in 1337.

For centuries, the mayor's chamber was the official meeting room of the mayor and city council. In 1752, local MP George Bowes paid £72 to have the room 'repaired and beautified' with oak panelling that bears his coat of arms.[26] The fine Jacobean fireplace originated from the Red Lion Inn and was donated to the city by its owner, Walter Scruton, when the inn was sold to Durham University in 1847. Carved in oak, the piece features figures of a king, a gentleman and a soldier.

Hardwick's scheme, refreshingly modest by Victorian civic standards, unified a group of buildings much altered over the centuries. Durham Town Hall has retained a civic role despite changes in local government organisation. It remains a meeting place for the mayor and aldermen of the city.

*Left*: West window.

*Below*: Mayor's parlour.

Newcastle Town Hall

Newcastle upon Tyne is widely regarded as the capital of North East England. The city developed from a Roman settlement named Pons Aelius, in reference to a bridge built by the emperor Hadrian in the second century. Recognising the town's strategic position, Robert Curthose, the eldest son of William the Conqueror, built a wooden castle here in 1080. This was the *Novum Castellum* or 'New Castle' that gave the city its name. The wooden structure was rebuilt in stone in 1087 and again in 1168–78. In the nineteenth century, the coal trade, shipbuilding and heavy engineering transformed Newcastle into a powerhouse of the Industrial Revolution. The visionary builder Richard Grainger (1797–1861) replanned the town in the 1830s, creating an oasis of classical architecture that remains one of the finest urban centres in Europe.

Newcastle's civic leaders met at a guildhall on the quayside, but there was a growing perception that the town was deficient in civic buildings, with one journalist writing 'This important and growing town of Newcastle had for years stood in urgent need of a commodious and centrally situated building which would answer better than any existing structure in the town, the purposes of a Town Hall.'[27] Calls for better accommodation were answered in 1855–63, though the plan encountered public opposition due to the cost.

The site was cramped, abutting a corn exchange designed by John and Benjamin Green (1838–39), and Newcastle's leading architect John Dobson criticised its selection.[28] A limited competition was held in 1852 to obtain designs. Around thirty architects entered and their submissions were exhibited in the guildhall. A design by John Johnstone (1814–84) and William Alexander Knowles (*c.* 1829–72) won the second premium but, as their design was deemed most suitable, it was ultimately chosen. It seems that Johnstone had the knack of obtaining civic commissions whether or not he had won the competition, since he also designed Bishop Auckland Town Hall, having been placed second, and subsequently planned town halls for Hexham and Gateshead. The building was erected under Johnstone's personal superintendence. He did not even employ a clerk of works, suggesting that he intended to complete the project to the highest possible standard by overseeing every detail personally.

The foundation stone was laid by Newcastle's Lord Mayor, Sir Isaac Lowthian Bell. Robert Robson of Wideopen was the contractor, who also supplied the stone from his own quarries. The original contract with Robson was for £17,000, but due to improvements subsequently made by R. Wallace, the cost rose to £30,000.[29] The roof slates were supplied by Beck, with plumbing by Henderson, and painting and gilding by Greaves.

Newcastle Town Hall was one of the first in the country to make free use of classical and Renaissance styles, breaking with academic tradition. This eclectic approach became common in town hall design, affording flexibility in the planning of a notoriously complex building type. The main elevation, facing

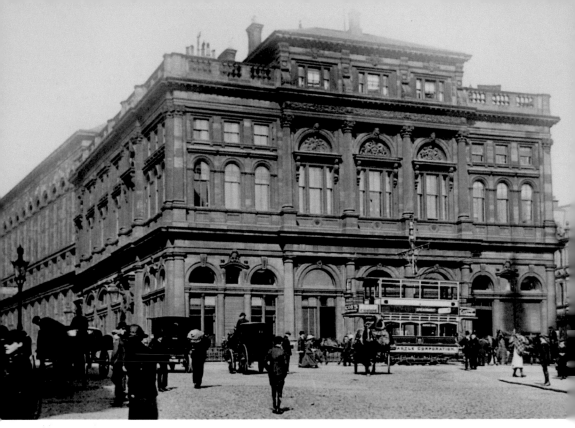

Newcastle Town Hall from St Nicholas' Square.

St Nicholas' Square, was said to be of 'Roman character', with Doric columns to the ground floor and Corinthian to the first.[30] However, these superimposed classical orders were interspersed with Renaissance-style, semicircular arches and the heavy entablature was enriched with a festooned frieze. The arches contained Newcastle's coat of arms and emblematic figures representing the 'trade and commerce of the Tyne.'[31] All of the ornamental stone carving was by the Newcastle builder and mason Walter Scott (1826–1910).

To offset the building costs, the ground floor was devoted to shops, banking offices and a hotel, generating £1,000 in rent annually. The council chamber was on the first floor facing St Nicholas' Church, now Cathedral. Dominated by a chimneypiece of fine Kenton stone and black and gold marble, the chamber was finished with a classical entablature and ornamental ceiling. The council chamber communicated with the principal committee room on the east side and the Town Clerk's office on the west. Corporate offices occupied the rest of this floor. The second floor and attic were devoted to public offices, generating around £2,000 in rent annually.

As the neighbouring corn exchange belonged to the corporation, the decision was taken to incorporate it into the town hall. At Johnstone's suggestion, the entire structure was pulled down and reconstructed on more substantial foundations. This enabled a new storey to be constructed above it, supported by wrought-iron

girders on cast-iron pillars and brackets manufactured by Hawks, Crawshay & Son of Gateshead. The floor of the new exchange was lined with 'the finest Caithness flags.'[32] The space was lit by two rows of windows and could be lit by gas at night, allowing it to be used for public meetings and dinners.

The new floor above the exchange housed a lavish music hall accommodating up to 2,400 people. Galleries ran around three sides, the fourth being occupied by an organ loft. The galleries were decorated with 'elegant iron work' by Donkin of High Friar Street and musical instruments were carved into the wooden pedestals supporting the railings.[33] Nicholson of Newcastle provided a concert organ for public entertainment, but it was intended to replace this at a later date with a larger organ from the celebrated London firm of Gray & Davison at a cost of £2,000.

The hall was lit by 'Venetian' windows by day and at night by sun-burners, ornamental gas jets like those used at Manchester's Free Trade Hall and installed by Bradford of Manchester. The panelled ceiling was enriched with plasterwork by the highly accomplished Ralph Dodds, well known for his work for John Dobson in some of Northumberland's finest country houses.

The entire building was extended 60 feet to the north at a cost of £13,000, including £9,000 for the site. 'Unsightly' medieval dwellings were cleared to make way for the new block, which tapered to a very narrow frontage facing the Bigg Market.[34] This was surmounted by a crude tower, which the *Newcastle*

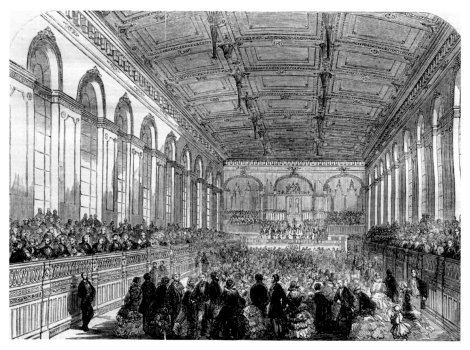

First-floor music hall.

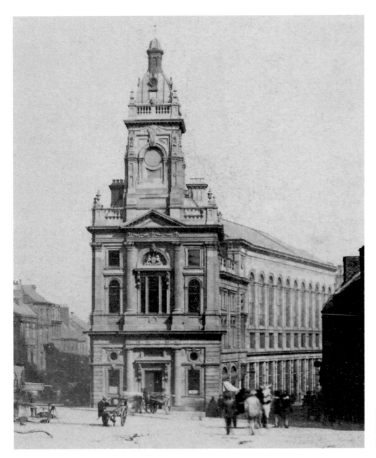

Newcastle Town
Hall from the
Bigg Market.

*Courant* nevertheless hailed as a 'bold campanile'.[35] A public clock was provided
for the use of market traders, as well as a large balcony for electioneering.

The siting of the town hall symbolised the shift of Newcastle's commercial
centre away from the quayside. Its tower complemented that of St Nicholas'
Church, establishing a symbolic axis between the buildings, signifying the unity
of Church and State. The *Newcastle Courant* was effusive in its praise: 'Every
inhabitant of this northern metropolis may point with pride to the new town hall
buildings as among the noblest ornaments of a town not wanting in architectural
beauty.'[36] In truth, the building failed to reach the standard of Dobsonian
classicism and *The Builder*, a leading architectural journal, was mixed in its
assessment:

> The narrow upper end is surmounted by an ill-shaped turret, and looks
> altogether uninteresting; but on the broader front on Mosley Street the same
> rather commonplace features (without the turret) have a far from bad effect, a
> result that seems almost entirely due to the greater breadth.[37]

Surveying Newcastle in 1881, *Building News* was less charitable, describing the town hall as 'a wretched confusion of old Classic, badly adapted from various works by Inigo Jones, Sir Christopher Wren and other classical architects.'[38]

Whatever its aesthetic merits, the town hall proved to be inconvenient as soon as it opened. Various proposals for improved facilities were put forward but it was not until 1950 that plans for a modern civic centre were approved. The old town hall deteriorated rapidly due to poor maintenance and the tower had to be demolished in the 1930s. A 1965 report declared that 'Newcastle's Old Town Hall was a monstrosity to begin with, but now derelict, dilapidated and filthy, it's a nightmare.'[39] The building was demolished in 1973, but fragments of its stonework were incorporated into the faceless office blocks erected on the site.

## Bishop Auckland Town Hall

Known as the gateway to Weardale, Bishop Auckland is situated at the confluence of the River Wear and the River Gaunless. The town became the country seat of the Prince Bishops of Durham in the twelfth century and Auckland Castle, the town's medieval treasure, has been the official home of the Bishop of Durham since 1832. An important market town since medieval times, Bishop Auckland grew in the nineteenth century as a commercial centre for the coalmining district of south-west Durham.

In 1858, the editor of the *Bishop Auckland Herald* stated that the town needed:

> A good, substantial and convenient building, the main feature of which should be its large room or hall with its requisite offices attached ... suitable for a missionary meeting or a ball room, a mechanics' institute lecture or a philharmonic society's performance, a theatre, a bazaar or any other of the multifarious uses for which such a room is required.[40]

A public limited company was formed in 1859 to build a town hall and market. Shares in the company were sold to raise money and a site was purchased, at that time occupied by old houses and a market cross.[41] To obtain designs, an architectural competition was held in 1860, attracting twenty-five entries. The competition was won by John Philpott Jones (1830–73) of London.[42] An Irishman from Clonmel, Jones moved to London in 1857 and formed a partnership with W. Swinden Barber. He later worked in partnership with Edward Salomons of Manchester. Eager to make his name, Jones entered many competitions, including those for Cork Town Hall, the Government Offices in Whitehall and Cork Cathedral.[43]

Jones actually produced two designs, one Gothic in style and one classical. He advised the directors to adopt the Gothic design as 'the more suitable, commodious and economical' due to its effect being achieved 'by outline alone' rather than

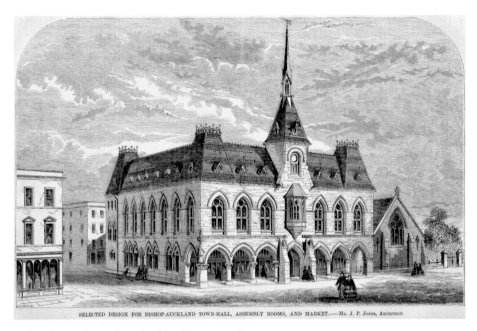

SELECTED DESIGN FOR BISHOP-AUCKLAND TOWN-HALL, ASSEMBLY ROOMS, AND MARKET.——Mr. J. P. Jones, Architect.

Jones' design for Bishop Auckland Town Hall.

expensive ornamentation.[44] The committee accepted his recommendation, partly because the Gothic church of St Anne lay immediately to the south and the committee 'thought best to design the building so as not to interfere with it by placing an Italian building close to it.'[45]

The choice of style reflected the shifting tastes of the 1850s and 60s, when monumental classicism was gradually eroded by the rising tide of Gothic, reflecting a romantic fascination with medievalism. E. W. Godwin's Gothic design for Northampton Guildhall (1861–64) was remarkably similar to Bishop Auckland Town Hall: both buildings were designed with a seven-bay façade surmounted by a central tower.

Architectural competitions became the standard method of awarding commissions in this era, but many were mismanaged, leading to accusations of corruption. The Northern Architectural Association, the region's major professional architectural body, objected to the conditions of the Bishop Auckland competition, arguing that the premium of £20 was not sufficient reimbursement for the winning design unless the architect was employed to conduct the works 'on the usual terms.'[46] Secondly, the Association observed that the Town Hall Company's intention to purchase any unsuccessful design for £5, thus retaining the copyright, was unacceptable, stating that 'Justice cannot be done to the building by any architect other than the author of such design.'[47]

The process of building the town hall was also marred by controversy. Although Jones was awarded the first premium, the committee subsequently appointed John Johnstone of Newcastle, who had come third in the competition, to modify his

design. Jones promptly asked for his drawings back and these were returned, but not before tracings had been taken. Johnstone simplified Jones' design to reduce costs. The seven-bay frontage was reduced to six bays, eliminating an oriel window and tower at the centre. The pavilion roofs were widened to compensate for the lack of a tower and plain walls were substituted for Jones' dramatic ground-floor arcade. Johnstone's work on the project helped him win commissions for town halls at Hexham and Gateshead in later years.

The original contract was for around £6,000, but costs rose to £9,000. Cordner of Stanhope was the contractor, with Bolam of Newcastle as clerk of works. Construction was delayed by a gas explosion in one of the ground-floor shops on 2 December 1862, when workmen smelled gas and went to investigate with a lighted candle.[48]

Built in 1860–62, the town hall resembles a French *hôtel de ville*, being one of the first in Britain to use French pavilion or 'Mansard' roofs, a feature that achieved wider currency in the 1880s. Named after French architect François Mansart (1598–1666), these distinctive elements helped to articulate the mass of large buildings and could be adapted for classical or Gothic designs.

The building was constructed in local sandstone with a roof of Welsh slate, laid in fish-scale bands. The lower storey was executed in fine-grained freestone, so named because it can be cut in any direction, and the upper storey 'tastefully blocked.'[49] The entrance is formed by two arches framed by a powerful column and pilasters with foliated capitals. A stone balcony rests on massive brackets, perhaps suggested by the balcony at Durham Town Hall. The first-floor windows are powerfully Gothic, with pointed arches and plate tracery. Between the French pavilion roofs rise an octagonal lantern and spire. The eventful roofscape received praise from *Building News*: 'The roof is of rather a remarkable construction, three of the outward corners being angle-roofed, and surmounted with iron palisading; while a beautiful, varnished oak spire springs from the centre, and gives the whole a pleasing and charming appearance.'[50] A clock was supplied by Watson of Manchester at a cost of £50 and installed by W. Buxton of Bishop Auckland.

The ground floor incorporated a mechanics' institute and offices for the Town Hall Company and Board of Health. A market hall lay at the rear of the building, with butchers' stalls on the ground floor and a raised gallery for dairy products. This space was roofed with a canopy of cast iron and glass and the spandrels of the arches were filled with ornamental scrollwork in blue and white.

On the first floor, a large assembly room lay behind the main frontage. Assembly rooms emerged as fashionable venues in the Georgian era and came to be viewed as important civic spaces, with entertainment programmes designed to elevate public taste. At the north end of the room was a recess for an orchestra and an organ for public entertainment. Jones intended the space to be roofed with a vaulted ceiling, but a simpler hammerbeam roof was built instead. Perhaps this was the reason the room was said to have poor acoustics.[51] The council chamber

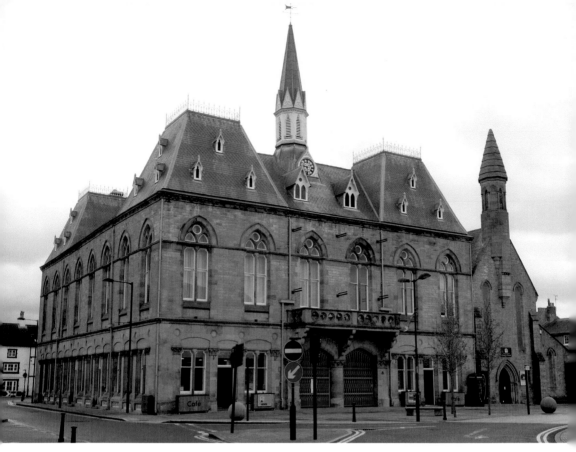

Bishop Auckland Town Hall.

lay above the market hall, lit by stained-glass windows displaying the arms of the borough.

The town hall remained the headquarters of Bishop Auckland's governing body until the urban district council was abolished in 1974. Marked for demolition, it was eventually saved by a public campaign and transformed into a library, art gallery and tourist information centre in 1990–92. Further refurbishment was completed in 2019–20 at a cost of £1.9 million. This created a new gallery to house the Durham Miners' Gala mural by the pitman painter Norman Cornish, previously on display at Durham County Hall.

## Darlington Old Town Hall

Darlington lies south of Durham on the banks of the River Skerne, a tributary of the Tees. Developing from an Anglo-Saxon settlement, its name derives from the Old English Dēornōthingtūn, meaning 'settlement of Dēornōth'. In the nineteenth century, the town prospered after enterprising Quaker families built the world's first permanent railway for steam locomotives between Stockton and Darlington, an event that marked the dawn of a new epoch.

A town hall was built at the junction of Tubwell Row and Prebend Row in 1808. Surviving images suggest that this was a Renaissance-style building with a cupola. When this building became inadequate, a larger civic complex was funded by the philanthropy of the Quaker industrialist Joseph Pease (1799–1872). Incorporating a town hall, market hall and clock tower, the complex was built on a site previously occupied by a meat market. This juxtaposition of town hall and market hall was common in the 1850s and 60s. The entire scheme was designed by no less a figure than Alfred Waterhouse (1830–1905), one of the greatest architects of the Victorian era. As a fellow Quaker, Waterhouse received many commissions from Pease and his family. His initial sketch for the town hall shows a three-storey building with a central gable and rose window. The completed building was much smaller, but still anticipates Waterhouse's design for Manchester Town Hall (1868–77), a masterpiece of civic architecture.

Waterhouse visited the site and sketched the existing buildings around the marketplace to ensure that his town hall would dominate its surroundings.[52] He massed the building in visual terms, giving it a strong silhouette and a commanding tower, one of the best he ever designed. As a result, the building was one of the few

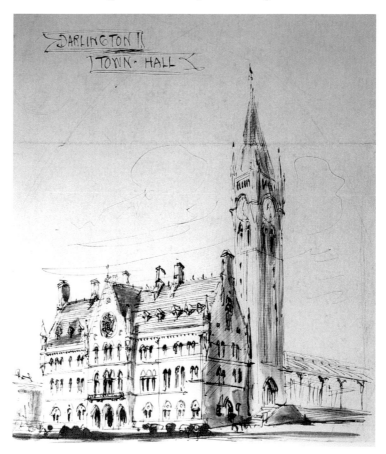

Waterhouse's early sketch for Darlington Town Hall.

town halls that was able to make a convincing statement on a limited budget, in this case £14,000.

The town hall proper (1861–64) is a modestly scaled building in cheap, stock brick. To reduce costs, there is minimal stone carving, with only simple stone bands to relieve the pale yellow brick. With its dormer windows and prominent chimneys, the town hall is more domestic than civic in character. Only the cast-iron balcony defines it as a civic building. Like the balconies at Durham and Bishop Auckland Town Halls, this platform was used for electioneering.

Extending north from the town hall, the market (1863) is a vast covered hall, built on a cast-iron framework. This was erected by Randal Stap of London at a cost of £7,815. Cast-iron construction was one of the great innovations in Victorian engineering, but contemporary taste usually dictated that such structures were 'beautified' by the addition of ornament. Such was the case at Darlington, where F. A. Skidmore of Coventry produced decorative ironwork. Tragically, a flaw in one of the girders caused it to collapse during an agricultural show in December 1863, killing a local farmer. Shaken by this event, Waterhouse never built another complete iron structure and demonstrated extreme caution whenever using iron in subsequent projects.[53] Each bay of the arcaded market has a separate roof ridge to provide light and ventilation.

The building's dramatic effect is concentrated in the clock tower (1864), which rises at the north-east corner of the market hall. Its design was based on principles expressed in John Ruskin's influential text *The Seven Lamps of Architecture*

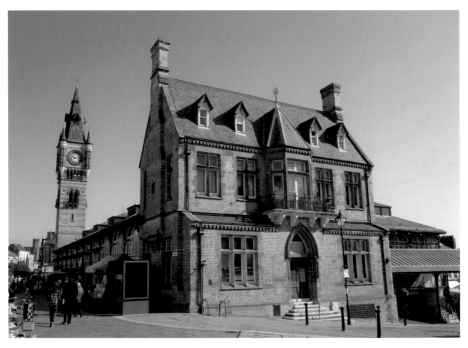

Darlington Old Town Hall.

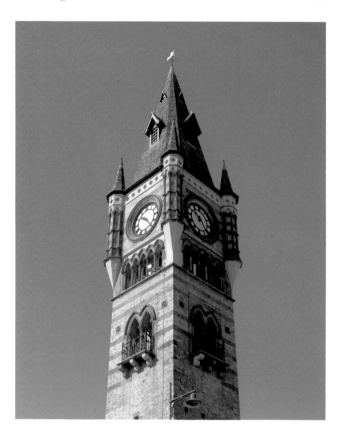

Waterhouse's dramatic
tower.

(1849), specifically the 'Lamp of Power', which held that certain buildings must
be considered in terms of their massing and should tend towards the sublimity of
natural forms such as mountains.

With its square plan and polychrome materials, the tower recalls the Gothic
campaniles of Italy. Significantly, the structure was a prototype for the larger tower
Waterhouse designed for Manchester Town Hall, culminating with a powerful
assembly of bartizans, clock faces and a piercing spire. Both the tower and clock
were donated by Pease. The clock was made by T. Cooke & Sons of York, while
the bells were cast by John Warner & Sons of Norton-on-Tees. These were the
sister bells to those inside the clock tower at Westminster, the most famous of
which is Big Ben. In 1899, the renowned clockmaker William Potts & Sons of
Leeds and Newcastle erected four skeleton cast-iron dials, each 7 feet in diameter
and filled with white opal glass, enabling the clock faces to be illuminated from
within.

Proposals to extend the building in 1891 came to nothing.[54] A new town hall in
North Lodge Park was suggested in 1927, but never built.[55] The council relocated
to a new town hall in 1970 and the old building was subsequently used by market
traders. A recent regeneration programme has transformed the Victorian building
into a visitor attraction with facilities for retail, dining and entertainment.

Hexham Town Hall

Hexham is a historic town in rural Northumberland, located near the confluence of the North and the South Tyne. Hexham Abbey was established as a Benedictine monastery in AD 674 by Wilfrid, a Northumbrian nobleman and bishop later revered as a saint. In the Middle Ages, Hexham became a market town for the surrounding agricultural area, as well as an important centre of industry and craft.

Many of Hexham's older structures were demolished to make way for new public buildings in the nineteenth century. Proposals for a town hall received support from the lord of the manor, Wentworth Blackett Beaumont. A limited liability company, the Corn Market and Public Buildings Company, was established in 1857 to build a town hall and permanent venue for weekly agricultural markets. Funds were raised by selling £5 shares in the company. After difficulties obtaining a building plot, Beaumont offered the present site. As this was some distance from the marketplace, Beaumont also funded the building of a macadamised road to link these important public facilities.[56]

Hexham Town Hall and Corn Exchange was yet another civic building designed by John Johnstone, following his town halls at Newcastle and Bishop Auckland. Born in Kilmarnock, Scotland, to a building contractor, Johnstone trained in London before establishing himself as an architect in Newcastle. His reputation was made by winning several commissions for major public buildings, enabling him to enjoy a successful practice. He never acquired professional qualifications but served as President and Vice President of the Northern Architectural Association. The fact that he was a freemason may help to explain why he

Portrait of John Johnstone.

received so many important commissions without necessarily winning the related competition. Sadly, Johnstone died suddenly in a brick yard while supervising the construction of schools in Low Walker.

At the laying of the foundation stone, Beaumont declared that 'Mr Johnson [*sic*] presented to us a scheme displaying great ability, and giving to us a building of almost palatial magnificence.'[57] This initial design had to be modified to reduce the cost, but the result was 'a building combining ornament with utility.'[58] The town hall was built in 1865–66 on the fine Victorian parade of Beaumont Street. Constructed at a cost of £8,000, it contained a corn exchange at the centre, with a town hall in the south wing and offices in the north, occupied by Lambton's Bank. A commentator described it as 'a chaste and elegant pile of buildings, admirably situated in the very centre of the town, fronting that noble and venerable structure the Abbey Church.'[59]

Built of freestone from the Prudham Quarry near Hexham, Johnstone's eclectic design exemplifies the 'Free Renaissance' style of which he was a pioneer. The façades make liberal use of Italian Renaissance elements, while the Mansard roofs are derived from French models. French Renaissance architecture became fashionable in the late Victorian period, exemplified by Johnstone's magnificent building for the Newcastle and Gateshead Gas Company (1884–86) in Newcastle, which was inspired by the great Château de Chambord in the Loire Valley.

Expressing the building's three main functions, the design follows a tripartite Palladian plan, with a prominent central block and outer pavilions. A rusticated base conveys the requisite strength, while the first floor is treated as a *piano nobile*,

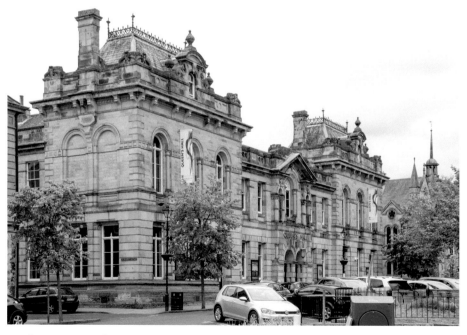

Hexham Town Hall. (Image © Billy Wilson)

with richer ornamentation. Arrayed with chimneys, urns and iron cresting, the building has a richly varied profile, typical of French exemplars.

The central bay forms an elaborate frontispiece, crowned by an open pediment. Originally, this was surmounted by a graceful figure of Ceres, the Roman goddess of agriculture. Her left hand clasped a cornucopia or horn of plenty and her right hand a sickle. The figure was surrounded by a rake, beehive and hay pike, as well as a sheaf of grain and a spade. These elements defined Hexham as the agricultural centre of Northumberland and stressed, through the symbolic language of classical gods, the importance of bountiful harvests to its economy.

The building was entered through iron gates made by Duncan of Newcastle. Inside, the corn exchange was a large, well-lit space with a cast-iron and glass roof. Dark green iron pillars rested on stone corbels and incorporated gas lamps, enabling the space to be used as an assembly hall at night. The iron and timber work was 'light and graceful, and tastefully coloured.'[60] In the town hall, the ceiling was formed of ornamental ribs supported by blue and white corbels and the dominant feature was a stained-glass window by Barnett of Newcastle.

The building was constructed by Thomas Bowman of Hexham, with John Hindson as clerk of works. The masonry was completed at a cost of £2,940, with joinery by E. Herdman (£1,758). Other contributions were as follows: plastering by Johnson of Carlisle (£415), plumbing by E. Stappart of Newcastle (£346), painting and glazing by W. Ellis of Hexham (£330) and slating by Henry Burn of Hexham (£230). The ironwork, pillars and roofing were supplied by H. Walker of the Percy Ironworks, Newcastle, for £480.

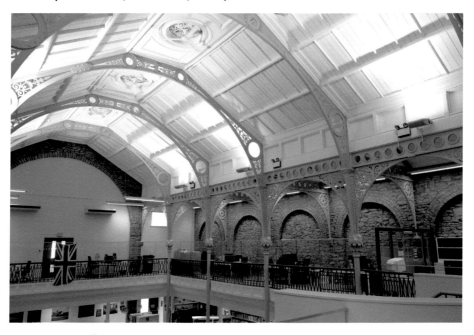

Former corn exchange.

Changing fortunes saw the building used as a music hall and cinema until it was acquired by Northumberland County Council and Tynedale District Council in 1981. Renamed Queen's Hall, it currently serves as an arts centre for rural Northumberland. Much of the interior has been refurbished, but it is still possible to appreciate the Victorian engineering of the former corn exchange.

## Gateshead Town Hall

Gateshead lies on the south bank of the River Tyne, connected to the city of Newcastle by a series of iconic bridges. The arrival of heavy industry fuelled Gateshead's development in the nineteenth century, leading to its designation as a municipal borough in 1835. The borough council met at various premises before a new town hall was proposed. The scheme was constrained by the low rateable value of property in the town, but the corporation eventually succeeded in erecting a civic building that declared Gateshead's aspirations.

The torturous process of selecting the design illustrates the problems that often arose from municipal patronage. A competition was held in 1863, but it was poorly managed and drew criticism from the architectural press. *The Builder* commented that only eleven architects competed and none from London. The journal suspected that this poor response was due to the vagueness of the competition conditions, which failed to provide two important pieces of information – the scale in which the designs were to be drawn and the sum of money that was available for construction. As a result, the designs were drawn in various scales and their estimated costs ranged from £8,000 to £25,000.[61]

The building was to provide the usual civic suite of council chamber, mayor's chamber, committee rooms and offices for borough officials. Judicial functions would be fulfilled by a courtroom and police cells, which were to be above ground level. For the wider community, there would be a large room for the meetings of public bodies and a hall to seat 1,000 people.

The council narrowed the designs down to those by Matthew Thompson, John Johnstone, John Lamb and John Edward Watson, before selecting Johnstone's design, which had an estimated cost of £8,750. Johnstone had designed town halls for Newcastle, Bishop Auckland and Hexham, proving his ability to bring the scheme to completion. Surprisingly, his design was Gothic in style, quite different from the building that was eventually constructed. It had no towers, pinnacles or buttresses, meaning that the only movement in the façade was afforded by the centre of the west front, which projected slightly and terminated in three gables. The plan provided a large entrance hall with a flight of steps leading to a central public hall. A separate entrance in Swinburne Place led to a county court and offices for the Board of Guardians. Despite its flaws, *The Builder* concluded that 'It would, perhaps, be difficult to offer a better digested plan than that to which they have accorded the first premium; while, on the other hand, if they have

the requisite funds, it would be unwise to adopt the elevations without further consideration.'[62]

Significantly, the second premium was awarded to John Edward Watson (1821–85) of Newcastle, who submitted an Italianate design with an estimated cost of £25,000. His façade was regarded as more attractive than Johnstone's, but his plan was less convenient. Ultimately, the town surveyor was instructed to produce a design synthesising the best elements of both entries and it seems that Watson's façade was reworked to fit Johnstone's plan.

The council then debated whether the building should face High Street or West Street. It was not until 1865 that it was agreed to build the town hall facing High Street at an estimated cost of £22,300. Even then, construction stalled when excavations for the foundations broke into the High Main Coal Seam, causing the collapse of neighbouring properties.

A second competition was held in 1867 for a town hall facing West Street and costing no more than £12,000.[63] In July, specifications and drawings were submitted by John Johnstone, Thomas Oliver and Austin & Johnson. Sunderland architect J. G. Brown was engaged to examine the specifications and determine the probable cost at which each design could be executed.[64] The Town Hall Committee recommended Oliver's design as the more suitable, with Austin & Johnson's coming next in order of merit and Johnstone's last.[65] Somewhat mysteriously, however, Johnstone was appointed as architect. Construction began in 1867, with a Mr Bulman as contractor, and was completed on budget in January 1870. The laying of the foundation stone attracted such a large crowd that one of the public stands collapsed, causing a fatality.

Due to the sloping site, the entire structure was built on a wedge-shaped plinth of rock-faced stone. The main façade is symmetrical, with subtle rustication to the ground floor. Like Johnstone's earlier town hall for Hexham, the building was designed in a Free Renaissance style, in this case with Venetian elements. However, it lacks the repose of Hexham Town Hall due to its more compact plan and greater vertical emphasis.

Johnstone was eclectic even by Victorian standards and was well known for his love of ornamentation and detail. The façade is articulated with superimposed pilasters, each bearing a symbolic emblem of Gateshead, including goats-head reliefs. These refer to the probable derivation of Gateshead's name from 'goats' head', meaning a headland inhabited by wild goats. The taller central block stands forward, housing the main entrance and three great windows. These are filled with excellent heraldic glass, although this was not introduced until the 1930s, probably by Thompson & Snee. Crowning the central bay is an ornate pediment, which originally bore allegorical figures of Commerce, Industry and Justice, representing standard civic values of the period. The central figure has since been removed. The whole group is surmounted by a statue of Queen Victoria, proclaiming Gateshead's loyalty to the Crown.

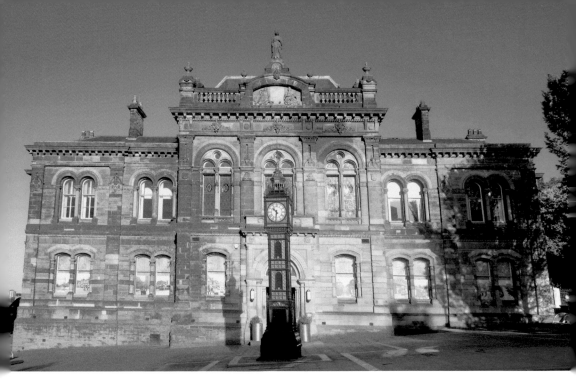

Gateshead Town Hall.

The entrance featured a colonnaded hall and stone staircase. To the right lay the civic spaces of council chamber, committee rooms and municipal offices, while judicial facilities including a magistrates' court, police station and cell block lay to the left. The town hall became the municipal heart of Gateshead. In the decades following its completion, a General Post Office (1873–75) and Free Library (1882–85) were built in its vicinity, the latter designed by Johnstone. This eclectic range of late-Victorian buildings gave Gateshead a dignified civic precinct.

The town hall lost its civic function when a modern civic centre was built in Regent Street in 1978–87. This was designed by the Borough Director of Architecture, D. W. Robson, using a neo-vernacular aesthetic of red brick and tiled roofs. The polygonal council chamber features stained-glass panels by Robson, entitled *The Gateshead Story*. The Victorian town hall was converted by Mackellar Schwedt and has been used by a number of social and cultural organisations. The building's future is uncertain, but it remains the only purpose-built Victorian town hall surviving in Tyne and Wear.

## Loftus Town Hall

Loftus lies in the south of the region, on the edge of the North Yorkshire moors. Its name is derived from *laghthus* meaning 'low houses' and the area has been inhabited since the seventh century. The town grew with the mining of ironstone in the nineteenth century to fuel the roaring blast furnaces of Teesside. Though

it served a small community, Loftus Town Hall warrants discussion due to its handsome design by an architect of national significance.

The building is a late example of the aristocratic patronage more common in the eighteenth century. For many years, local magistrates struggled to conduct their business due to the absence of a suitable venue. On the advice of his agent George Dale Trotter, Lawrence Dundas, the 3rd Earl of Zetland, resolved to erect a town hall. The commission was awarded to Edward Robert Robson (1836–1917), the most influential architect ever to emerge from the North East. His plans were approved in September 1877.[66]

Born in Durham, Robson was articled to John Dobson in Newcastle before working as an improver for Sir George Gilbert Scott in 1857. Commencing practice in Durham, he was appointed clerk of works to the cathedral and worked with Scott as the latter was remodelling the building. It is Robson we must thank for discouraging Scott from building a spire over the cathedral's central tower. In 1871, Robson was appointed surveyor to the London School Board and in this role he developed the model for the giant board schools commissioned as a result of the Elementary Education Act of 1870. The majority were designed in the fashionable 'Queen Anne' style, which synthesised Dutch elements with features from English buildings produced during the reign of Queen Anne (1702–14).

Portrait of E. R. Robson.

Loftus Town Hall was a rare civic commission for Robson, who produced a design in a late Gothic style. This was exhibited at the Royal Academy of Arts in May 1879 and *Building News* commented wryly that 'Mr E. Robson for once has forsaken "Queen Anne" in his town hall at Loftus-in-Cleveland (1152), a building beautifully drawn by Mr W. Rushworth.'[67] Although Robson was a leading exponent of the Queen Anne style, there was a consensus that it lacked the gravitas needed for civic buildings and it was rarely used for town halls.

The building was constructed by Thomas Dickenson of Saltburn, with James Patterson as clerk of works. The £5,000 cost was considered small for the building, the savings being achieved by using stone from local quarries belonging to the Earl of Zetland.[68]

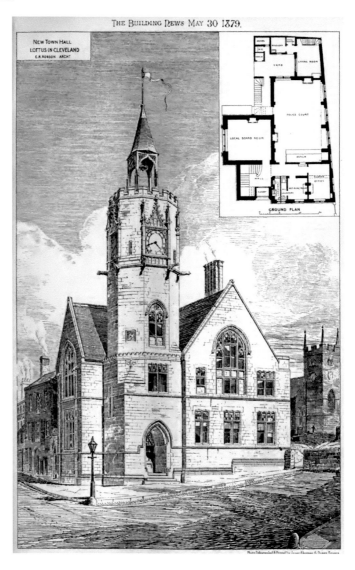

Robson's design for Loftus Town Hall.

Standing on a corner site, the building is anchored by an octagonal tower, forming a landmark for Loftus. The tower rises bold and severe, but its corona is enriched with radiating gargoyles, Gothic ornament and a crenelated parapet. The structure recalls Christopher Wren's famous Tom Tower at Christ Church College, Oxford (1681–82). A more immediate influence may have been the town hall at Bradford-on-Avon, which is similar in general form.

Built of hammer-dressed sandstone, the main elevations are dominated by broad gables and windows with strong, simple tracery. Small ogival windows alleviate the smooth expanses of stone. A panel bearing the coat of arms of the Dundas family, including the motto *Essayez* ('Strive'), appears on the tower, together with a fleur-de-lys motif. The clock was funded by subscriptions from the tenants of the Zetland estate in memory of Thomas Dundas, 2nd Earl of Zetland and uncle of the building's benefactor.[69] Curiously, there is no clock face to the south because the residents of South Loftus refused to contribute to the fund.

The interior retains a fine entrance hall with an encaustic-tiled floor. The ground floor housed a council chamber, police court, boardroom and clerk's office. A staircase with cast-iron Gothic balustrade led to an assembly hall, newsroom and office on the first floor. There were rooms for the Mental Improvement Society and parish church Sunday school, as well as a large hall for public meetings, reflecting the lofty ideals of Victorian paternalism.[70] The result was a building 'which for

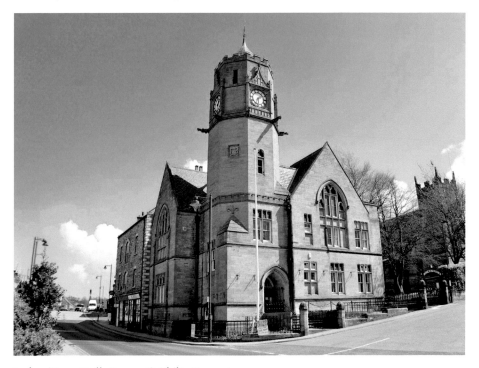

Loftus Town Hall. (Image © Philip Barnes)

style and excellent workmanship will bear comparison with any erection in Cleveland.'[71]

The town hall remained in the ownership of the Zetland estate until 1948, when it was purchased by Loftus Urban District Council for £2,000. The ground floor was then tenanted by the National Insurance Board.[72] Although the council vacated the building in 1996, it still organises functions in the town hall.

## Middlesbrough Town Hall

Middlesbrough lies south of the River Tees, within the historic district of Cleveland. The site of a monastic cell in Anglo-Saxon times, its name refers to its 'middle' location between the religious houses of Durham and Whitby. Until the nineteenth century, Middlesbrough was no more than a small farmstead. Its extraordinary transformation into an industrial metropolis began in 1828, when a group of Quaker businessmen led by Joseph Pease selected this flat, marshy land south of the Tees as the site for a new coal port. To provide labour, a new town was built on a grid-iron plan around a central market square. Following the discovery of ironstone in the Cleveland Hills, Middlesbrough became a world-leading centre of iron and steel production, known as 'Ironopolis'.

The first town hall was built in 1846 at the centre of the market square, but as the embryonic town continued to grow, a new symbolic focal point was required. Powers for a new town hall were granted by the Middlesbrough Improvement Act of 1866. A site was purchased in 1873 and Pease asked the great Victorian architect Alfred Waterhouse to design the building. Pease had previously awarded several private commissions to Waterhouse, a friend and fellow Quaker. Waterhouse produced a design in 1873–75, but this was never built due to a slump in the iron trade. Instead, a competition was held in 1882 and eleven sets of drawings were received. Waterhouse was appointed to judge them at a salary of 100 guineas. The first premium of £300 was awarded to a plan marked 'Law and Order'. This was revealed to be the work of George Gordon Hoskins (1837–1911) of Darlington, an architect who had served as Waterhouse's clerk of works on several projects. Although the competition was anonymous, it is likely that Waterhouse recognised Hoskins' drawing style. As a longstanding member of the Darlington corporation, Hoskins would also have had a thorough understanding of the building's requirements. His competition entry indicated that the building could be faced in either stone or a combination of brick and stone. After winning the commission, he inspected the principal buildings of Middlesbrough and concluded that:

> Stone buildings suffer too greatly from the effects of the smoke caused by the several industries of the district, and consequently assume a dark and gloomy monotony, whereas buildings of brick, if liberally relieved with stone dressings, present a pleasing contrast, even under the inevitable effects of smoke-stain.[73]

*Left*: Portrait of G. G. Hoskins.

*Below*: Hoskins' initial design for Middlesbrough Town Hall.

Hoskins decided on a combination of brick and stone and published a design prescribing these materials in January 1883. At some point, however, this decision was reversed, because the final building is faced entirely with Yorkshire stone.

Middlesbrough Town Hall was built in 1883–89 by E. Atkinson at the astonishing cost of £130,000. The design retains elements of Waterhouse's 1875 plan, with a great hall arranged behind the frontage and a tower and entrance

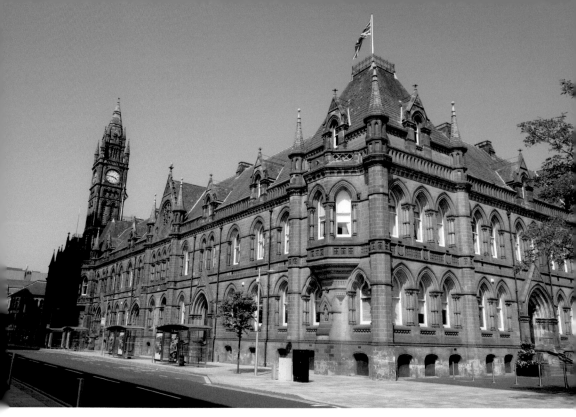

Middlesbrough Town Hall.

porch at one corner. Majestic in conception, the town hall was designed in a French Gothic style of the thirteenth century. Hoskins had used the same style in his Middlesbrough branch of the Backhouse Bank (1872–73), which in many ways was a prototype for the town hall. Unsurprisingly, the design also shows the influence of Waterhouse's famous town hall at Manchester.

The complex has a simple layout, with a commanding town hall on Corporation Road and municipal buildings to the south. The main elevation is symmetrical, with pavilions at the ends, braced by octagonal buttresses. Although crowned by Mansard roofs, the pavilions project only slightly, meaning that there is little sense of movement in the façade. The central porch was not part of Hoskins' original design. It seems that this was added after a disaster occurred in one of Hoskins' previous buildings. In June 1883, 183 children were killed in a stampede at the Victoria Hall in Sunderland. A critical factor was the fact that the exits opened inwards. Hoskins had designed the ill-fated building in 1872 and was forced to defend himself in the national press. It seems that fears of a recurrence prompted the building of the porch at Middlesbrough to create an additional exit. Unfortunately, the porch obscured the lower half of the central windows and produced an awkward effect.

The main entrance lies on the Albert Road elevation, which resembles the east face of Manchester Town Hall. Above the door is a shield displaying Middlesbrough's coat of arms and its motto *Erimus* ('We shall be'), reflecting the

sense of continual transformation that characterised this energetic Victorian new town. An immense clock tower rises above the entrance, culminating in a majestic spire. Soaring to 170 feet, this structure alone cost £882. The clock tower allowed Middlesbrough's iron merchants to schedule their meetings. This was particularly important since the town's main trading place, the Royal Exchange, was built without its proposed clock tower.

The façades are arrayed with allegorical sculpture, enshrining the paternalistic ideals of Middlesbrough's ruling class. Statues representing Commerce, Painting, Literature and Music portrayed the town as an enlightened metropolis where capitalism was the wellspring of the arts. A fifth figure, representing Science, had to be omitted due to the addition of the porch. Figures of St George and the Dragon stand over the main entrance, proclaiming Middlesbrough's nationalist loyalties, while a figure of Justice symbolises the courthouse and police cells. These fine statues were sculpted by H. T. Margetson of Chelsea at a cost of £50 each.

The interior houses perhaps the finest council chamber in the North East. Stalls for borough officials are arranged along one wall. Councillors' seating is arranged in a semicircle around a grand chair for the mayor, emphasising the importance of this office. However, Middlesbrough Town Hall is unusual in having no mayor's parlour, which was generally considered an essential feature.

Still surviving is the magistrates' court, which was hailed, hyperbolically, as 'the finest court of its description in the country.'[74] The space is lit by a skylight set into an elaborate lantern ceiling. Suspended glass panels display the scales and sword

Statues by Margetson representing Commerce and Painting.

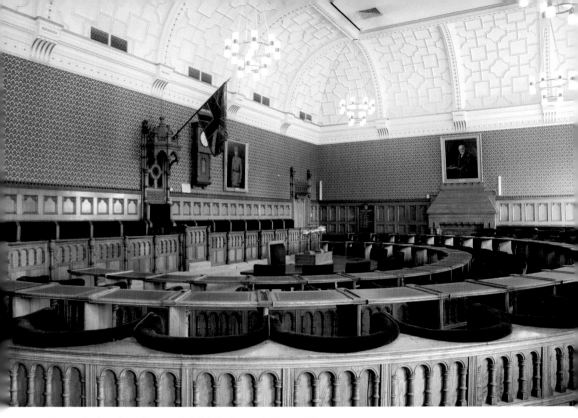

Council chamber. (Image © Middlesbrough Council)

of justice and the national flowers of England, Scotland and Ireland, declaring that justice reigns throughout the kingdom.

The largest interior is the concert hall, which features a double hammerbeam roof of local steel, a visual celebration of the town's primary industry. The space was lit by wonderfully grotesque dragon gargoyles clutching gas lamps in their mouths, giving the fantastical impression that they were breathing fire into the chamber. The walls originally displayed full-length portraits of Pease and other members of Middlesbrough's industrial pantheon, portraying these men as the town's benevolent founding fathers and their hegemony as the basis of its prosperity.

Amid this heady symbolism, the building was also functional and practical. The floor of the hall was built using a system of fireproof construction patented by Charles Colton Dennett in 1857 and revised in 1863. The floor rested on concrete arches supported at intermediate points by iron girders and the concrete was made of broken stone embedded in calcined gypsum plaster rather than cement. Hoskins had already used this system at the Backhouse Bank. As well as protecting against fire, the system obviated the need for columns in the police drill hall that lay immediately below, making the space more convenient for manoeuvres. No doubt members of the Northern Architectural Association were impressed by these features when Hoskins led a tour of the building in July 1887.[75]

The municipal buildings lie behind the town hall. Arranged on a monastic plan around a quadrangle, these were in keeping with the building's neo-medieval style, while also illuminating the offices within. The Gothic façade screened a warren of segregated local government departments. Curiously, there was no means of internal circulation, meaning that ten entrances and thirteen separate staircases were provided. Facilities included offices for borough officials, a free library and offices for the School Board.

Middlesbrough continued to grow in the twentieth century, despite the gradual decline of its steel industry. A modern civic centre was erected alongside the Victorian building in 1971–73. Designed by Borough Architect J. V. Wall, this is a brutalist structure in engineering brick, braced by a concrete exoskeleton. The design anticipates the Sir Thomas White Building at Oxford (1972–75), which, like the civic centre, was constructed by Sir Ove Arup. One of Britain's last Gothic town halls, Middlesbrough's civic palace still embodies the pride of this great Victorian metropolis.

## Sunderland Town Hall

Sunderland lies at the mouth of the River Wear and its name derives from its status as a land 'sundered' by the river. This geographical location was also the source of Sunderland's prosperity, enabling the town to develop into a thriving coal port and world-leading centre of shipbuilding. However, the history of Sunderland's municipal architecture is a tragic saga involving a much-loved Victorian town hall and a controversial but innovative civic centre, both of which fell prey to the wrecking ball.

Sunderland's first town hall was Holy Trinity Church (1719) in the thriving East End, where the town's elected officials met in a vestry room. This was superseded by a purpose-built exchange on High Street East (1814). Sunderland's continued growth soon necessitated a town hall on a grander scale. A competition was held in 1874 for municipal buildings on two possible sites in Mowbray Park.[76] Thirty designs were received, but as no professional assessor had been appointed, the competition was mismanaged and drew criticism from the architectural profession. The preferred design was a Gothic extravaganza by Frank Caws (1846–1905), the architect responsible for Sunderland's Orientalist fantasy, the Elephant Tea Rooms (1873–77). However, Caws was disqualified on a technicality. Several councillors then pointed out that building in Mowbray Park would infringe the right of citizens to use it for recreation. The entire scheme was abandoned.

A second competition was held in 1886 and this time Alfred Waterhouse was appointed as assessor at a fee of 80 guineas, though some councillors still objected to the expenditure.[77] The winning design, submitted under the pseudonym 'Stabilitas', was by Brightwen Binyon (1846–1905) of Ipswich. Binyon was born at Headley Grange, Manchester, and educated at a Friends' School in Kendal,

before training in the Manchester office of Waterhouse, a fellow Quaker. After travelling around Europe, he settled in Ipswich and undertook many commissions in Suffolk. Binyon entered six competitions for civic buildings during his career, winning several. The Sunderland competition was dogged by accusations of corruption due to the links between architect and assessor. Nevertheless, Binyon's plans were exhibited at the Royal Academy and published in the architectural press.

The contract was let to E. H. and S. Allison of Sunderland for £25,120, with John Robinson as clerk of works. Construction was overseen by local architects John (1835–99) and Thomas Tillman (1852–92) and completed at a cost of £27,000. Furnishings and fittings brought the total to around £50,000.

The plan was rectangular, with two quadrangles to illuminate the interiors. Rising from a powerful rusticated base, the façades were designed in an eclectic style, combining bold classical forms with Renaissance details. Pavilions stood at the corners, arrayed with giant columns of the Corinthian order. These were surmounted by Mansard roofs, the hallmark of French Renaissance architecture. In this respect, the building complemented the Tillmans' design for Sunderland Museum and Library (1876–79) nearby. The entire structure was faced with Prudham stone from Northumberland.

The centrepiece was a prominent clock tower with four cast-iron dials, crowned by a cupola and lantern. Made by William Potts & Son, the clock was similar to those at Rochdale and Bolton town halls. The bells, weighing 7.5 tons in total, were supplied by John Warner & Sons.[78]

Significantly, Binyon's composition for the grand entrance was replicated at Swindon Town Hall, which he completed in 1890–91, thus preserving a tiny vestige of Sunderland Town Hall's original design in built form. The entrance hall and main staircase were worked in Denwick stone from Northumberland, with columns of polished red granite.[79] These formed a spectacular scenographic procession that swept visiting dignitaries up to the lavish council chamber and mayor's parlour.

The building was practical as well as grand. All the floors were constructed using Homan and Rodger's patented system of fireproof flooring. The walls of the courtyards were faced with glazed bricks made by the Farnley Iron Company of Leeds, helping to illuminate the interior by reflecting light into the rooms. While many town halls had towers, most were built for visual impact and had no functional justification. The tower of Sunderland Town Hall was an exception. The building was heated by means of low-pressure steam, each room being supplied with coils and fresh air inlets and ventilated by means of extraction flues carried into a shaft in the tower. These heating and ventilation systems were supplied by Frank Ashwell of Leicester.

Binyon had an opportunity to showcase his building when the Northern Architectural Association held its second summer gathering in Sunderland in June 1890. The members were met at the railway station by a number of 'Sunderland

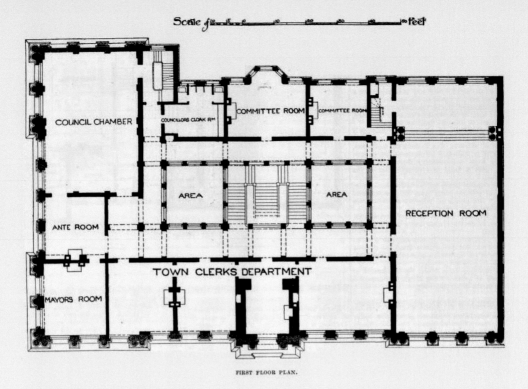

Scale $\frac{1}{8}$ ............ 10 ....... 20 ......... 30 ........... 40 ...... 50 feet

COUNCIL CHAMBER

COUNCILLORS CLOAK RM

COMMITTEE ROOM

COMMITTEE ROOM

AREA

AREA

RECEPTION ROOM

ANTE ROOM

MAYORS ROOM

TOWN CLERKS DEPARTMENT

FIRST FLOOR PLAN.

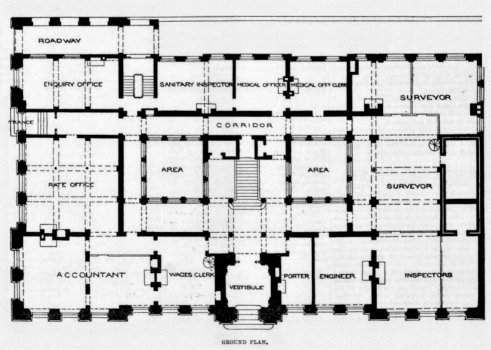

ROADWAY

ENQUIRY OFFICE

SANITARY INSPECTOR

MEDICAL OFFICER

MEDICAL OFFR CLERK

SURVEYOR

ENTRANCE

CORRIDOR

RATE OFFICE

AREA

AREA

SURVEYOR

ACCOUNTANT

WAGES CLERK

VESTIBULE

PORTER

ENGINEER

INSPECTORS

GROUND PLAN.

Plans of Sunderland Town Hall.

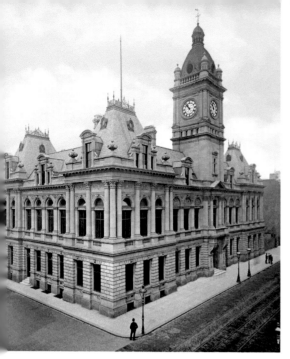

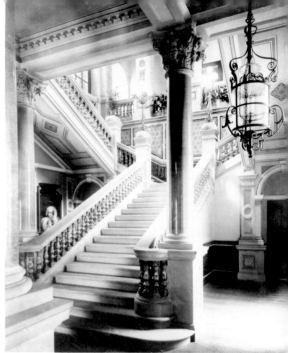

*Above left*: Sunderland Town Hall. (Image © Sunderland Antiquarian Society)

*Above right*: Grand staircase. (Image © Sunderland Antiquarian Society)

*Below*: Council chamber. (Image © Sunderland Antiquarian Society)

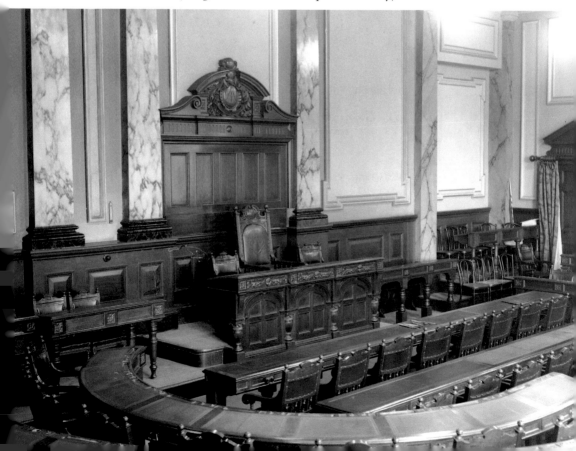

gentlemen', and Binyon conducted them on a tour of the town hall.[80] Opened that same year, his building was recognised as a sign of Sunderland's growth and prosperity:

> Few towns even in the North of England have made greater strides of late years than the important town at the mouth of the Wear. Its population has increased by leaps and bounds; its residential suburbs have grown in beauty year by year; and its public buildings have kept pace with the march of improvement and prosperity. The latest addition to the architectural attractions of Sunderland is the new Town Hall ... It will be seen from the accompanying engraving that the new building is really a handsome pile.[81]

Despite this optimistic assessment, the town hall was soon found to be cramped and inconvenient. Plans for an extension were sought in 1903, and Wills & Anderson of London won the competition with a façade identical to the existing building. Their design featured a tower to balance the existing clock tower and involved moving the entrance to the centre of the extended façade to maintain symmetry. The estimated cost of the extension was £27,000.[82] However, it was never completed.

The duties of local government eventually outgrew the building, prompting the construction of a new civic centre in 1964–70. Various alternative uses for the noble Victorian edifice were suggested, but these were rejected by the council, allegedly eager to claim a £100,000 redevelopment grant. Sunderland Town Hall was demolished in 1971 and its stone was incorporated into walls in the grounds of Silksworth Hall, an ignominious fate for the embodiment of Sunderland's civic pride.

## Corbridge Town Hall

Lying 16 miles west of Newcastle, Corbridge is one of the most picturesque towns in Northumberland. It developed from a succession of Roman forts built to control river crossings on the Tyne. These were eventually supplanted by Corstopitum, the most northerly town in the Roman Empire and an important garrison that supplied troops to Hadrian's Wall. In Saxon times, Corbridge became the capital of Northumbria and the church and monastery of St Andrew were built using stone from the Roman wall. The town grew in status in the late Victorian period, when a rail link to Newcastle was established.

In 1881, the local worthy Isaac Walton proposed building a town hall, and a limited liability company was formed, with Walton as honorary secretary. Architects of the district were invited to submit designs. The competition attracted twenty-two competitors and Frank Emley (1861–1938) was the winner. The son of a stonemason, Emley was born in Gateshead and educated in Switzerland. He was articled to the important firm of Oliver & Leeson of Newcastle, before working as an assistant to Charles Hodgson Fowler of Durham and to William Searle Hicks of Newcastle, both prominent ecclesiastical architects. He travelled

in France and Belgium and commenced independent practice in Newcastle in 1887 but emigrated to South Africa for health reasons around 1893, practising in Johannesburg. According to the *Newcastle Courant*, 'This gentleman has designed a building elegant in appearance and substantial in construction.'[83] Significantly, the site was donated by Farquhar M. Laing, a wealthy businessman who resided nearby at Farnley Grange, and the foundation stone was laid by his wife Jane. The masonry was executed by Lawson and Turnbull and the joinery by J. Turnbull.[84]

Built in 1887, the town hall is a charming building, compact, symmetrical and dominated by a graceful tower. The ground floor is partially clad in rusticated masonry, much like Vanbrugh's town hall at Morpeth, but the upper storey is executed in irregular 'snecked' stonework, recalling simple vernacular buildings. Indeed, the design reflects the generalised neo-vernacular aesthetic that emerged in fashionable architecture of the day, influenced by the Arts and Crafts principle of honouring local building traditions. Specifically, it recalls the work of Norman Shaw. Contrasting with the stonework are quaint 'Ipswich windows', a detail Shaw used in several projects. Ultimately, these were derived from vernacular buildings of Suffolk and its county town.

Laing's patronage also funded the tower, which 'added much to the picturesqueness of the building.'[85] This is ornamented with English Renaissance details. Two cherubs hold aloft a crown, indicating that the town hall was built to commemorate Queen Victoria's Golden Jubilee in 1887. Above is the famous

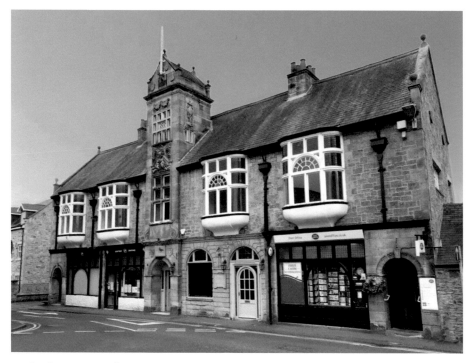

Corbridge Town Hall.

Corbridge seal, the town's historic emblem. These elements 'make up a somewhat quaint and decidedly pleasing building.'[86]

Inside was a large hall with a gallery, accommodating 500 people. The ground floor was occupied by shops and a post office. On the first floor were a library and reading room, as well as a room for the Corbridge Young Men's Christian Association. The result is a graceful building in harmony with its rural setting and free of the bombastic effects common in Victorian town halls. A contemporary commentator was not unjustified in writing 'Modern Corbridge will open the doors and rejoice in the possession of a town hall, just as ancient Corbridge, an important Roman town, rejoiced in its forum.'[87]

## Thornaby Town Hall

Thornaby-on-Tees lies south-east of Stockton in the historic North Riding of Yorkshire. Its name, derived from the old Norse for 'Thormod's farmstead', was established around AD 800, when Halfdan Ragnarsson, the first Viking king of Northumbria, gave the land to a nobleman named Thormod. Rapid development came in the nineteenth century, when the Stockton & Darlington Railway was extended to Middlesbrough. Thornaby's position on the banks of a navigable river led to the establishment of manufactories and shipyards.

The town hall was built in anticipation of Thornaby being designated a municipal borough by royal charter in 1892. The site lay in a developing area occupied by clay pits near South Stockton railway station. A limited competition was held in 1890, eliciting ten sets of plans. The winner was James Garry (1850–1918) of West Hartlepool, who submitted a design in the familiar Free Renaissance style of the period. Garry was born in Bishop Auckland, where he received architectural training under William Vickers Thompson from 1864 to 1869. After working as an assistant to Thomas Oliver in Newcastle, he commenced practice in West Hartlepool in 1870 and travelled in Belgium, France, Italy and Norway. The building was constructed by W. C. Atkinson of Stockton in 1890–92, with a Mr Iley as clerk of works. The cost was £4,500, with furnishing bringing the total to £7,000.[88]

The town hall has two main elevations that converge to a chamfered corner bay, thus resolving the difficulty of the sharply angled site. The focal point is a cupola that rises over the entrance, featuring a clock face. This is typical of the cupolas with which smaller towns like Thornaby had to make do in place of more substantial towers. Nevertheless, the structure was considered to be 'of somewhat bulky proportions'.[89] The clock itself was made by William Potts & Son and donated by Thornaby's first mayor, William Anderson.

Both elevations are richly modelled in red brick, sandstone and terracotta, producing vibrant colour effects. The plain bricks were made in Normanby, but these were supplemented with moulded bricks made by J. C. Edwards of Ruabon,

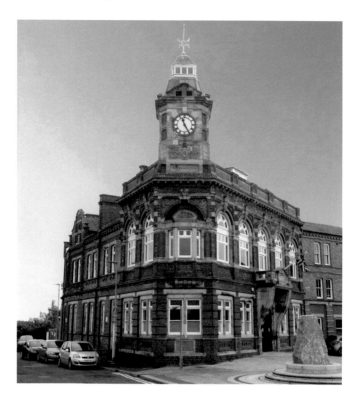

Thornaby Town Hall.

a leading manufacturer of architectural ceramics. The stone came from the Dunhouse Quarry near Barnard Castle.

The entrance lies between giant, sweeping brackets that support a balcony. Ornamental entrance gates were supplied by Crossthwaite of Stockton. Internally, the entrance hall is lit by a glazed dome, allowing light to play over a splendid floor of Minton's tiles. Within the porch was a handsome polished wooden screen with stained glass, carved by Arrowsmith of London. Beyond this hall was a central vestibule surrounded by offices for the School Board and other bodies. The National Provincial Bank had premises in the building, as did the local gas company, generating rent for the corporation.

An impressive circular stone staircase with iron balustrade spiralled up to the council chamber and mayor's parlour on the first floor. The doors to the council chamber were oak-panelled and emblazoned with the arms of the new borough. The seating, arranged in a semicircle, was executed in walnut with Moroccan leather in sage green. All the furniture was designed by the architect and made by Balfour & Sons of Glasgow at a cost of £525. It was skilfully designed to accommodate monuments to Thornaby's civic pantheon. Set into the fireplace is a clock made by Potts & Son and donated by the architect. Surmounting the fireplace is a pedestal intended for a bust of Thornaby's first mayor. Around the chamber are arched recesses, intended to be occupied by portraits of the borough's 'prominent public men.'[90]

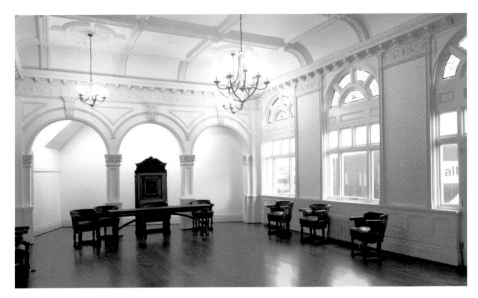

Council chamber.

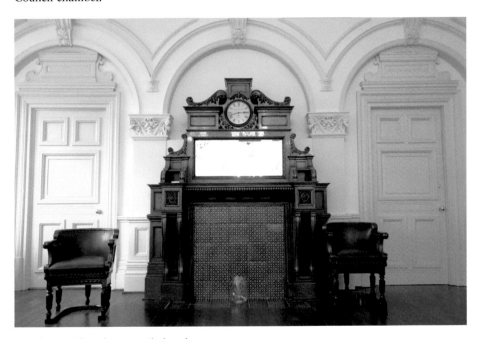

Fireplace within the council chamber.

Sir Nikolaus Pevsner was critical of the building, describing it as 'a totally undistinguished design on a visually most unsuitable site.'[91] Nevertheless, it signalled Thornaby's independence from Stockton and made the requisite display of civic pride. The town's coat of arms and date of its designation as a borough are displayed on a stone panel on the clock tower, together with its optimistic motto 'Always Advancing'.

The building served as the headquarters of Thornaby Borough Council until the county borough of Teesside was formed in 1968. Neglected and deteriorating rapidly, Thornaby Town Hall stood as a forlorn echo of vanished idealism. However, an extensive programme of renovation was initiated in 2017, supported by £900,000 from the Heritage Lottery Fund.

## Hartlepool Town Hall

Hartlepool is dramatically sited on a headland that projects from the County Durham coast into the North Sea. An abbey was founded on this windswept site in AD 640, where St Hilda's Church stands today. The surrounding village grew in the Middle Ages, its harbour serving as the official port for the County Palatine of Durham.

Much like Middlesbrough to the south, modern Hartlepool was a product of capitalist enterprise. Ralph Ward Jackson (1806–80), a Stockton solicitor, secured parliamentary permission to build a new harbour south-west of the ancient village in 1844. Jackson developed the new township of West Hartlepool, building new streets and public buildings on what had been sand dunes. However, such rapid development brought problems of overcrowding and poor sanitation, and Jackson subsequently admitted that he had planned the town without giving due consideration to these matters. Surveying the two Hartlepools in 1862, *The Builder* remarked that:

> One is an old town, once a small fishing place, gradually developed by maritime commerce into consequence; the other, a new town brought into existence by the speculative enterprise and energy of one man – Ward-Jackson – commenced on too large a scale in its main features, without a proper reference to the maintenance of decency and order in small things.[92]

West Hartlepool soon eclipsed the original village, prompting the town improvement commissioners to build an administrative base for their own use. Early proposals for a town hall and market stalled amid controversy surrounding the utility and cost of such buildings.[93] However, a later scheme for a town hall and technical school was realised in 1895–97.[94]

The building was designed by Henry Arthur Cheers (1853–1916) of Twickenham. 'Harry' Cheers was born at Great Boughton near Chester. Commencing independent practice in Leeds in 1879, he worked in Liverpool for two years before moving to Twickenham in 1882. Cheers entered nine competitions for civic buildings during his career and designed town halls at Oswestry (1893), Hereford (1904) and East Ham (1903), generally in a flamboyant style combining Renaissance, Jacobean and Elizabethan motifs and constructed of red brick and stone. His work was no doubt influenced by a sketching tour in the Netherlands, Germany and France taken in the 1870s.

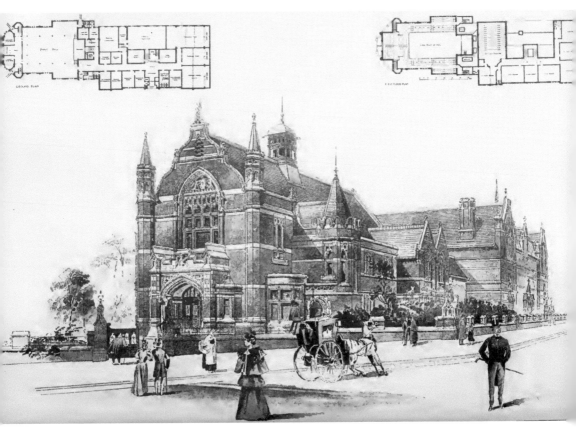

Cheers' initial design for Hartlepool Town Hall.

Hartlepool Town Hall was expected to cost £12,000, with a further £2,430 for the land and £3,000 for furnishings. The contractor was Thomas Dickinson of Middlesbrough and West Hartlepool, while A. Dermont was the clerk of works.[95] Designed in the Gothic style, the building is surprisingly ecclesiastical in character. This impression is compounded by low ranges that break out at the sides, resembling church transepts. The exterior is faced with red Accrington pressed bricks and dressings of Dunhouse stone, producing a chromatic contrast. The stone was quarried from Cleatlam in County Durham.

The entrance lies within a broad porch crested with battlements. Above rises a tall window with formalised Perpendicular Gothic tracery. The head of the window is filled with a splendid representation of the borough's coat of arms, indicating that this is not a church but a civic building. Griffin finials and octagonal turrets give the building a vivid profile, but the crowning gable forsakes the Gothic spirit in favour of a Flemish Renaissance style. With this stylistic synthesis, the building emulates the magnificent town halls of Flanders.

A technical college was built in conjunction with the town hall immediately to the west. Now demolished, this was also designed by Cheers and built of the same

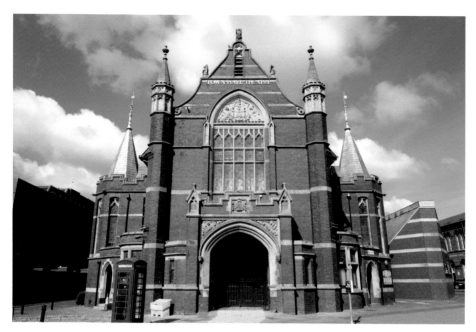

Hartlepool Town Hall.

materials.[96] The fact that technical schools were integrated with a civic building illustrates how vital technical education was considered to be for the regional and national economies. Significantly, the foundation stone was laid by the chairman of the Technical School Committee, rather than the mayor. His speech celebrated 'the indomitable pluck and enterprise of the British workman and Britain's captains of industry', and declared that the aim of the institution was 'to secure and hold fast our position in the industrial world.'[97]

Old Hartlepool established its own civic building, Hartlepool Borough Hall, in 1865. This is an impressive Italian Romanesque-style edifice designed by Charles J. Adams (1840–79) of Stockton. The old and new townships amalgamated in 1967 and the combined authority moved into a new civic centre in Victoria Road, an approachable composition of angular brick terraces designed by Clifford Culpin & Partners (1973–76). West Hartlepool Town Hall was converted into a theatre in 1977 and the adjoining technical college was demolished. Tim Ronalds Architects extended the theatre in *c.* 1994, adding a low, angular block at the north-east corner. Executed in red brick with bands of sandstone, this harmonises well with the Victorian building, while asserting its own modernity.

## Jarrow Town Hall

Jarrow was established in the Saxon era, on marshy lands south of the River Tyne. The early settlement was called Gyrwe, from the Anglo-Saxon 'gyr', meaning mud

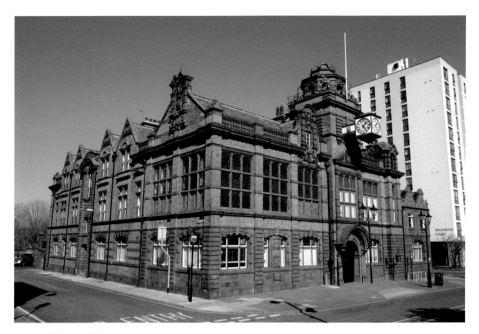

Jarrow Town Hall.

or marsh. The Northumbrian nobleman Benedict Biscop founded the monastery of St Paul at Jarrow in AD 684–85, and, together with its twin monastery at Monkwearmouth, it became the greatest centre of learning in the kingdom, possessing the largest library north of the Alps.

The modern town expanded during the nineteenth century as workers were drawn to the shipyards on the Tyne. Jarrow became a municipal borough in 1875. By the end of the century, it was felt that 'The machinery for carrying on the work of the Corporation was inadequate for a growing and rising borough like Jarrow.'[98] The council agreed to demolish its premises and build a town hall on the same site.[99] This would include a courthouse, since 'the people of Jarrow had agitated for a county court for 30 years.'[100] The corporation borrowed £10,000 to fund construction; furnishings cost an additional £2,000.[101] The result is one of the best-preserved civic buildings in the region.

The building was designed by Fred Rennoldson of South Shields in a Free Renaissance style tending towards the baroque, which underwent a revival in the Edwardian period. Perceived as an English Renaissance style, baroque became almost an official idiom for governmental buildings throughout Britain and its colonies, a triumphalist expression of national and civic pride. The style was noted for its exaggerated use of architectural sculpture, a trend encouraged by the 'New Sculpture' movement.

Construction was completed by James C. Nichol of South Shields, with James Crieve as clerk of works.[102] The external facing consists of bright red brick and terracotta, giving the building a fiery red colour, much like Durham's recently

completed Shire Hall (1898) and Middlesbrough's Dorman Museum (1904). These buildings reflect the turn-of-the-century fashion for architectural ceramics and chromatic façades. Terracotta was widely used in the period, providing relatively inexpensive ornament that was resistant to atmospheric pollution. However, modern critics have commented on the 'disastrous results' of using terracotta in small town halls, and Pevsner found Jarrow Town Hall 'vulgar' due to its excessive ornamentation.[103]

Typical of the Edwardian baroque manner, symmetry is offset by a stolid tower. The ground floor is clad in terracotta, moulded to resemble the rusticated masonry of earlier baroque buildings such as Vanbrugh's town hall at Morpeth, as well as the work of James Gibbs. The visual effect is striking but was achieved by repeating a number of basic decorative elements. Indeed, the building featured in a catalogue issued by the terracotta manufacturers J. C. Edwards of Ruabon in 1903.

The entrance lies in the base of the tower under an immense canopy. The openwork tower is the most attractive part of the building, enriched with a 'broken' pediment containing the borough's coat of arms. It culminates with an octagonal cupola, like those published in Gibbs' *Book of Architecture* (1728), an important source for the Edwardian baroque school. The recently completed town halls of Ilford and Colchester exhibited similar towers. The roofline is broken at irregular intervals by Flemish gables enclosing rich cartouches. The lyricism of these gables suggests the influence of the art nouveau style that was flourishing on the Continent in this period.

Opened by Sir Charles Palmer on 15 June 1904, the building's interior is equally memorable, with lavish mosaics, marble and stained glass. Corporation officials were housed on the ground floor. The council chamber housed a mayor's dais and councillors' seats in the usual horseshoe formation. In the centre was accommodation for the town clerk and officials. These excellent fittings are in fumed oak and red Moroccan wood. Facing the mayoral dais is a gallery for the public, over which is an *opus sectile*, a type of mosaic composed of individually shaped pieces rather than uniform squares. This was made by James Powell & Sons in 1904, based on a painting of old Jarrow by the important regional artist J. W. Carmichael. The windows of the chamber were originally filled with plain leaded glass, but stained glass 'of costly design' was introduced at a later date.[104] The county court was on the first floor, reached by a separate entrance in Wylam Street.

In 1936, the town hall was a fitting starting point for the legendary Jarrow March, when 200 unemployed workers, accompanied by 'Red' Ellen Wilkinson MP, marched to London to petition for the right to work. The building therefore has great historical significance for the people of South Tyneside and the wider labour movement. Its role as a seat of local government ended when South Tyneside Council was established in 1974, but it is still used by the council as a customer service centre.

*Above*: Foyer of Jarrow Town Hall.

*Left*: Council chamber and mayor's dais.

## South Shields Town Hall

The ancient settlement of South Shields lies at the mouth of the River Tyne. Around AD 160, the Romans built the fort of Arbeia in this defensible location to guard the main sea route to Hadrian's Wall. Its name, meaning 'fort of the Arabs', referred to the presence of bargemen from Mesopotamia (modern-day Iraq) within the garrison. The township of South Shields was established in 1245 as a fishing port, its name referring to the cluster of 'scheles' or fishermen's dwellings south of the Tyne. In the nineteenth century, industries such as

coalmining, glassmaking and chemical manufacturing brought prosperity and rapid expansion.

South Shields' first municipal building was a manorial courthouse built by the Dean and Chapter of Durham in 1768. South Shields became a municipal borough in 1850 and the corporation acquired the building for use as a town hall five years later. When the old building became inadequate for the expanding town, the corporation obtained parliamentary powers to build a splendid new town hall at a cost not to exceed £45,000. An anonymous competition was held in 1869 and the first premium was awarded to John Johnstone, whose design was submitted under the optimistic pseudonym 'I Work to Win'.[105]

The competition drew accusations of corruption, which, if true, may help to explain how Johnstone received so many civic commissions without winning the competition. An anonymous letter published in *Building News* stated 'There is not the slightest doubt but that the above competition has not been fairly conducted.'[106] The author noted that a councillor, Mr Young, had informed the *Newcastle Chronicle* that Johnstone had sent circulars containing his initials to council members. Consequently, when Young voted for 'I Work to Win', he knew for whom he was voting.[107]

Another letter, by a competitor, observed that Johnstone had not submitted a single elevation and that the only indication of the design's architectural character came from an exterior perspective that 'quite ignored the vulgar need for chimneys' and left two façades to the imagination.[108] A recurring problem in architectural competitions of this era was the tactic of submitting artful perspectives of the building to influence non-specialist committees, who could appreciate a picturesque drawing better than a technical plan. The instructions stated that the building's principal faces were to be of pressed red brick with white stone dressings, but 'I Work to Win' devised a building that was faced with ashlar stone. According to the correspondent, 'These technical objections alone, apart from the alleged use of "back stair" influence, should have disqualified "I Work to Win" from receiving the first premium.'[109] The letter was signed 'Hard work and no pay'.

Ultimately, this scheme came to nothing. Further proposals were rejected until an open competition was held in 1901, judged by John Belcher, a leading baroque architect. This was won by Ernest Edward Fetch (1866–1929) of London. Following a change in specification, another competition was held the following year for a more costly building. Again, Fetch was the winner, and his design was built in 1905–10 at a total cost of over £78,000. Born in Cambridge, Fetch was articled to Theodore Knolles Green from 1884 to 1887. He studied at the Royal Academy Schools in 1887 and worked in the offices of William Henry Romaine-Walker and Augustus William Tanner in 1888–93.

The corporation experienced some difficulty in finding a contractor able to construct the building. A tender of £46,450 5s 11d from a Mr Riley was accepted initially,[110] but this was withdrawn and the contract was instead awarded to Robert Neill & Sons of Manchester, whose tender was for £47,900.[111] Further

problems arose when the site was found to be 'soft and treacherous' due to the presence of sand. This was removed at considerable expense.[112] Construction came to a standstill when the architect refused to accept the flooring material supplied by the contractors.[113] The corporation finally agreed to remove this flooring and replace it with materials purchased on the recommendation of the architect.[114]

The South Shields Municipal Reform League objected to what it saw as the excessive cost of furnishing the building, pointing out that 'while the councillors and the officials were to be palatially housed, the rate payers would receive no benefit from the new buildings because there was no public hall.'[115] Observing that the estimated cost of the furnishings was £7,500, the League stated that 'it was questionable if the corporation were on the borderline of absolute illegality because they were spending the public money absolutely for their own comfort.'[116] As a result, the furnishing committee met to devise ways of reducing the cost. The specifications for the forecourt were changed for the same reason. Local Heworth stone was substituted for granite, wrought iron for bronze and the ornamental lamp standards, expected to cost £800 each, were simplified.[117]

Transcending all these difficulties, South Shields Town Hall emerged as the region's finest civic building of the Victorian and Edwardian era, a true civic palace, resplendent in baroque style and serene despite its grandeur. The elevations are composed of stone from the Springwell Quarries near Gateshead, supplied by the Northern Stone Firms. Springwell stone was also used for Newcastle's Emerson Chambers (1903–04) and Sunderland's Empire Theatre (1907).

The entire edifice stands on a powerfully rusticated base with bands of rock-faced stone. From this rugged plinth, the symmetrical façade rises with great dignity and repose. The end bays break forward as pavilions, designed in strict classical terms. The centrepiece is a sublime aedicule that frames the entrance, recalling the epic-scaled work of J. M. Brydon. Giant Ionic columns rest on monumental plinths enriched with sculptural reliefs representing the arts. Upon these paired columns, an open pediment supports the boldest allegorical sculpture of any town hall in the region. Carved by Hibbert Charles Binney (1872–1951), the figures represent the 'trade and commerce of the Borough of South Shields.'[118] A heroic Neptune and eroticised nymph of the Tyne recline on the pediment, the latter reflecting the influence of the art nouveau style then flourishing in Europe. A triumphant figure of Britannia is seated at the apex.

The symmetry of the façade is offset by the dramatic addition of a clock tower at the north-west corner. Subversion of symmetry is characteristic of Edwardian baroque architecture. The tower tapers subtly, culminating in a cluster of Ionic columns that form a noble belfry. Statues representing the four seasons stand at the corners, again sculpted by Binney. The graceful tower is surmounted by a copper weathervane in the form of an Elizabethan galleon that proudly proclaims the town's maritime prowess.

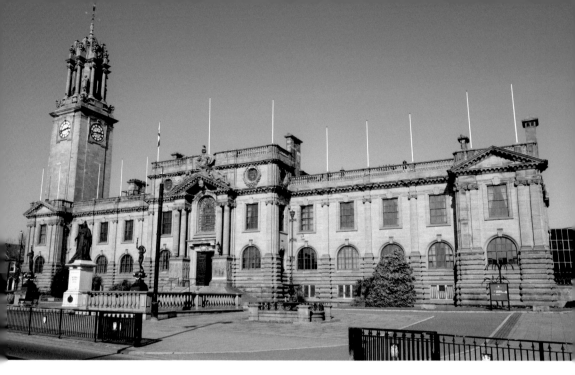

*Above*: South Shields
Town Hall.

*Right*: Central aedicule.

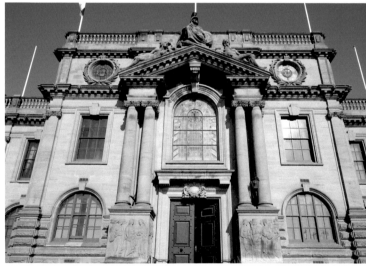

The interior is equally fine. From the magnificent foyer, the visitor is expertly choreographed through a graceful sequence of columned, marble halls. The climax is the domed council chamber, where councillors' seating is arranged in a horseshoe formation around a mayor's dais, its superb woodcarving recalling the work of Grinling Gibbons. In the building's lower reaches, the corridors are lined with glazed bricks in extraordinary, iridescent green. With its superb façades and lavish interiors, South Shields Town Hall is the finest example of Edwardian baroque architecture in the region, grand in conception and exquisite in execution.

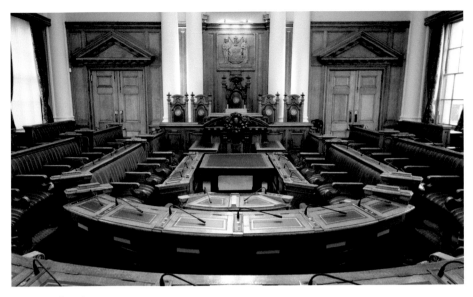

Council chamber.

Glazed bricks lining the corridors.

## Wallsend Town Hall

Wallsend derives its name from its location near the eastern termination of Hadrian's Wall, where the Romans built the fort of Segedunum. By the nineteenth century, Wallsend was a major centre of shipbuilding, producing famous vessels

such as the *Mauritania* and *Carpathia*. It was here that Charles Parsons launched the revolutionary *Turbinia* in 1894. Wallsend became a municipal borough in 1901. Soon after its charter of incorporation was granted, the need was felt for new municipal buildings. Three possibilities were suggested: the erection of new buildings, the renting of adopted buildings, and the erection of a temporary iron structure. The Municipal Buildings Committee inspected the town halls of Jarrow, West Hartlepool and Felling and proposed a dedicated municipal building on open land south of High Street East.[119]

Competitive plans were invited, and the architects were instructed to allow half the building to be erected immediately and the remainder at a future date when funds became available.[120] The building was designed by Edwin Fewster Waugh Liddle (b. 1869) and P. L. Brown of Mosley Street, Newcastle, in the Edwardian baroque style. Liddle was born in Darlington, the son of Newcastle architect Robert F. W. Liddle. He commenced practice in 1893 and was a member of the Society of Architects.

The town hall was constructed in 1907–08 at a cost of £15,557. Franklin & Son of Newcastle were the contractors.[121] The design is in the spirit of John Belcher's town hall at Colchester (1897–1902), using the same architectural language and material palette of red brick with sandstone dressings. The base features banded rustication, breaking around the arched openings, and the engaged columns that articulate the upper storey are of the Ionic order. The stately façade is punctuated

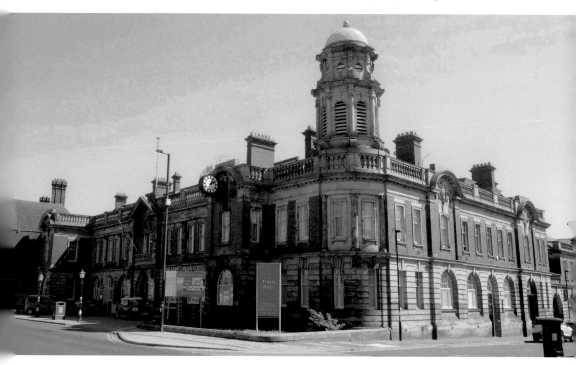

Wallsend Town Hall.

by grand pavilions, segmental pediments and ornate cartouches. The central entrance is framed by giant pilasters and a powerful open pediment, within which is a sculptural relief of the town's coat of arms. A clock made by William Potts was donated by the borough's first mayor William Boyd and installed on the western pavilion.[122] Symmetry is broken by a rotund tower at the north-west corner. This delight in asymmetry is typical of the Edwardian baroque manner and echoes the design of South Shields Town Hall (1905–10).

The municipal buildings, as they were known, included a police court, fire station and public baths arranged along Lawson Street. Internally, the council chamber was panelled in fumed oak and lit by stained-glass windows, each displaying heraldic shields that celebrated aspects of Wallsend's industry and commerce. The building's benefactor, William Boyd, is represented, along with aldermen and burgesses of the town and the 'C Pit' of Wallsend Colliery.

When the town hall was completed, the *Jarrow Express* was able to state that 'The borough can boast of a fine block of municipal buildings, erected at a remarkably small cost.'[123] The building continued to serve as a seat of local government until 2008, when the council moved to new premises at Cobalt Business Park. The Edwardian building was sold to a developer in 2014 and renovated to create a conference centre under the name 'Town Hall Chambers'.

## Newcastle Civic Centre

The greatest of all civic buildings in the North East is Newcastle Civic Centre, the administrative and ceremonial heart of the region's leading city. Shaped by the doctrines of modernist architecture, the building responds to a range of international influences, yet it also embodies Newcastle's cultural identity by embracing historical allusion and metaphor. Though lavish in execution, incorporating expensive materials from around the world, it was conceived as an icon of democracy and transparency in local government.

By the twentieth century, Newcastle's Victorian town hall had become too small to function. Proposals for a replacement culminated in a 1945 city plan that envisioned a new civic precinct on Newcastle's northern perimeter, incorporating a civic centre and colleges of higher education. In February 1950, the Municipal Buildings Committee requested the City Architect, George W. Kenyon (1908–76), to prepare plans. These were approved on 20 December 1950, but due to national restrictions on capital expenditure, work was delayed until 1958. As a result, the building was decidedly old fashioned when it was finally opened in 1968. Nevertheless, Newcastle Civic Centre is an important example of post-war British architecture and one that confidently represents Newcastle on an international stage.

Born in Liverpool, Kenyon studied under Sir Charles Reilly at Liverpool University's celebrated School of Architecture. He subsequently studied town planning with Sir Patrick Abercrombie and worked in the office of Shreve, Lamb

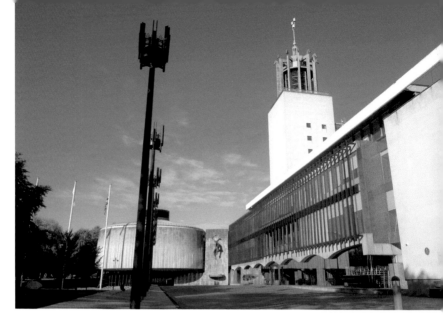

Newcastle Civic Centre.

& Harmon in New York City, contributing to the design of the Empire State Building (1930–31). The civic centre was designed to complement new educational precincts for Rutherford College and Newcastle University to the east and west respectively, all integrated through comprehensive landscaping. According to the architect, 'The creation of these projects, together with the redevelopment proposals for the Central Area, will undoubtedly serve to bring the city to its rightful place in the forefront of the great cities of Europe.'[124] Preparation of the site involved the demolition of housing and a former Eye Hospital. The centre was built in stages from May 1960 by Sir Robert McAlpine & Sons of Newcastle, using reinforced concrete frame techniques. Construction was completed in 1967 at a total cost of £4,855,000.

As we have seen, the Victorian concept of a town hall was an imposing monument of civic power. Newcastle Civic Centre was conceived as a more democratic structure, symbolising the ideals of post-war Britain. There is no dominant façade or grand entrance. Instead, the building was designed to articulate the functions of local government: the twelve-storey administration block, council chamber, banqueting hall and rates hall are all visually distinct. This campus system was pioneered at the Dessau Bauhaus (1925–26), one of the foundational works of modernist architecture. Emerging in Europe, modernism was a radical movement that aimed to transform society through rational design. Rejecting traditional styles, it embraced modern construction methods such as prefabrication and pursued a minimalist aesthetic of geometric forms and clean lines.

An asymmetrical play of volumes anchored by a stark tower, Kenyon's design was clearly inspired by the Dutch modernism of Willem Dudok's Hilversum Town Hall (1928–30). Despite the severity of its forms, the entire complex is finished to an exceptionally high specification, using lavish materials such as marble, Norwegian slate and exotic woods from Africa, Burma, Honduras and India. The use of marble, amounting to over thirty species across 49,000 square feet, was

unrivalled by any building erected in Britain during the previous half century and the extraction of the stone was personally supervised by Kenyon at the quarries. This emphasis on luxurious materials suggests the influence of Bauhaus master Ludwig Mies van der Rohe, whose work combined formal purity with a rich materiality.

The building is dominated by the giant administration block, its western face treated as a resplendent white tower. The superstructure is clad in Whitbed Portland stone, a Jurassic limestone from Dorset. The same material was used for government buildings at Whitehall, giving it appropriate connotations for a seat of civic administration. Equally resonant is the Wren Stone, located within the quadrangle. This is one of the original stones selected by Sir Christopher Wren for St Paul's Cathedral and bears his sign of approval. It lay unused in the quarry and was donated to the city by the Stone Firms in 1965, in recognition of the use of Portland stone at the civic centre. The building's gleaming white surfaces, echoing modernist prototypes, are relieved by a grid of grey Cornish granite and spandrels of green Broughton Moor stone from Cumbria. Throughout the building, the windows are double-glazed and set in bronze frames.

Modernism was conceived as a universal language of design, stripped of regional signifiers in order to transcend national boundaries. Departing from this universalist ethos, the civic centre uses a range of historical references to crystalise Newcastle's cultural identity. According to the architect, 'The city has a wealth of tradition arising from its long history as the major city of the North East of England and the Border area, together with its worldwide industrial and commercial associations, all of which provide a vast fund from which an artist may draw inspiration.'[125] Fundamentally, Kenyon was continuing the Victorian tradition of weaving historical references into the building's fabric. However, his contextual approach also reflected a growing concern within architectural theory for the *genius loci* or spirit of a place, the unique, indefinable character formed by topography, history and countless other factors. The concept was later theorised by Norwegian architect Christian Norberg-Schulz.

The trident-like carillon tower was strategically positioned to align with the northern route into the city, forming a landmark. The treatment of its lower stage was deliberately restrained to emphasise the crown, which is formed from copper-clad flying buttresses, echoing the spire of St Nicholas' Cathedral. The carillon can be illuminated with an electric beacon, directly referencing the practice of burning a brazier in the spire of St Nicholas' to guide keelmen on the Tyne. The iconic seahorses forming the corona were sculpted by John Robert Murray McCheyne (1911–82), Master of Sculpture at King's College in the University of Durham, now Newcastle University. Made of fibreglass and copper, these motifs are derived from Newcastle's coat of arms and signify the city's status as a port.

Positioned at the base of the tower, the council chamber is an elliptical volume in textured concrete. Its form and placement recall the chapter houses of medieval cathedrals. Emphasising its status, the chamber is raised on x-shaped iron *pilotis*,

like those used by Mies van der Rohe in works such as the Villa Tugendhat (1929–30). It thus forms a *porte-cochère* to shelter passengers as they alight from vehicles. Beneath the chamber is one of the building's main entrances, protected by cast-aluminium gates by Geoffrey Clarke (1924–2014). A pioneer of modern British sculpture, Clarke experimented with new materials and processes and developed the unusual method of making models in polystyrene and casting them in aluminium rather than bronze. As one of Herbert Read's 'Geometry of Fear' sculptors, Clarke addressed the emotional and psychological trauma of the post-war generation in works such as his powerful *Crown of Thorns* at Coventry Cathedral. With their expressive, neo-medieval forms, his gates for the civic centre suggest a phalanx of swords guarding the door.

Extending north, the banqueting hall has the character of a medieval fortification, consciously evoking the castles of Northumberland. The material is roach-bed Portland stone, which has a more prominent fossil encrustation than the stone used elsewhere, making this block more rugged than its counterparts. The windows resemble medieval arrow loops and there is a suggestion of castle ramparts to the roofline.

Although the civic centre was not conceived by Newcastle's infamous council leader T. Dan Smith, it was completed during his tenure and complemented his misguided utopian vision of Newcastle as the 'Brasilia of the North'. Smith installed much contemporary art in the building, emulating Stockholm Town Hall (1911–23), which had demonstrated the value of municipal artworks on a grand scale. This provision went beyond the Victorian tradition of merely ornamenting façades with sculpture, aiming instead to form a democratic 'people's gallery'. Each of the selected artists had a national or international reputation, as well as close affinities to the city, and all worked in liaison with the architect.

David Wynne's sculpture *River God Tyne* evokes Newcastle's ancient past, alluding to the Roman concept of river deities. When in use, water pours from the raised hand and cascades over the body, animating the sculpture. The bronze figure, the largest erected in Britain since the time of Rodin, is backed by a wall of riven Norwegian slate. Born into a naval family, Wynne served in the Royal Navy during the Second World War, before beginning a degree in zoology at Cambridge. Recognising his skill in animal drawing, his tutors soon urged him to concentrate on art and he established himself as a sculptor in 1950. His work was accessible rather than academic and his contribution to popular culture included introducing the Beatles to the Maharishi Mahesh Yogi in the 1960s.

The most theatrical element of the whole complex is the parade of nine flambeaux designed by Charles Sansbury (1916–89). Born in Watford, Sansbury taught art at various schools until 1957, when he was granted a leave of absence from Bedlington Grammar School. This enabled him to complete a degree in fine art at King's College, where he came under the influence of Victor Pasmore (1908–98), a pioneer of abstract art in Britain. Discovering that sculpture was

Wynne's sculpture *River God Tyne*.

his forte, Sansbury developed an intense interest in the assembly of metal forms. Consisting of castellated motifs, his flambeaux at the civic centre can be lit to create flaming beacons, symbolically reviving the ancient custom of burning tar barrels outside Newcastle's guildhall in Elizabethan times.

Using a monastic typology, the civic centre forms a quadrangle around a tranquil landscaped garden. Originally, this lay open to St Thomas' Green, fulfilling the architect's intention to make the building a model of transparency. The cloister was accessed via a cathedral-like undercroft supported on columns of Alpine grey granite. Sculptural metal screens by Sansbury were embedded in the ground and these could be raised to close off the quadrangle when necessary. Unfortunately, these were removed when the centre was remodelled in 2019.

The North East of England has many historical links to Scandinavia, beginning when Vikings raided the monasteries of Northumbria and continuing in Newcastle's trade links across the North Sea. Acknowledging this history, the building incorporates many allusions to Scandinavian culture. For example, the quadrangle bears a clear resemblance to Oslo City Hall (1931–50), which is similarly clad in brick, with a regular disposition of windows, and augmented with bronze sculptures.

Suspended over a plane of water, David Wynne's sculpture *Swans in Flight* was inspired by *The Swans from the North* by Danish poet Hans Hartvig Seedorf Pederson. The swans represent the countries of Scandinavia in order of their creation as independent states. Together, these references recall the aesthetic of Nordic Romanticism common in Scandinavian architecture since the nineteenth century. Ultimately, these Nordic elements serve to define Newcastle as a northern capital.

Quadrangle with Wynne's sculpture *Swans in Flight*.

*Swans in Flight* is typical of the popular animal sculptures that dominated Wynne's work. These were based on close study of animals within their natural habitats, including many hours swimming with dolphins. Perhaps this explains why both of his sculptures at Newcastle incorporate water as an essential element.

Entering the building, the great hall is lined with black Norwegian Otta slate and irregular bands of English oak, imparting a rich textural contrast. The floor is lined with pale green Verde Viana marble from Portugal. The base of the tower is powerfully expressed in a wall of Portland stone, inscribed with a dedication to King Olav V of Norway, who opened the building in 1968. It was intended to enrich this wall with sculptures commemorating local events, but none was ever installed.

Rising around the great hall is a grand staircase with a banister of mahogany and aluminium. The jewel-like cascade of an immense crystal chandelier dominates the space. This is the work of Alfred Burgess Read (1898–1973). Departing from the industrial aesthetic he developed after visiting the Bauhaus, the chandelier incorporates historical elements from Newcastle's coat of arms.

Great hall with Read's chandelier.

Another work that crystallises Newcastle's history is a glass screen engraved by the New Zealand artist John Hutton (1906–78). The ethereal figures include Mithras, an ancient Persian deity who was worshipped by Roman soldiers stationed on Hadrian's Wall, and mysterious beings from Celtic mythology – Brigantia, a goddess associated with the northern Brigantes tribe, Coventina, goddess of wells and springs, and the Three Mothers, signifying fertility. The second scheme mythologises 'the inventive genius of Tyneside's famous sons.'[126] George Stephenson is represented by the steam locomotive, Charles Parsons by the steam turbine, Joseph Swan (who was actually born in Sunderland) by the electric lightbulb, and W. G. Armstrong by the rifled gun. Appearing almost celestial when light shines through them, the etched figures strongly recall Hutton's *Screen of Saints and Angels* at Coventry Cathedral.

The banqueting hall is approached via a reception area floored in grey and white Arabescato marble from Italy. Evoking medieval castles, the hall displays 'a strong affinity with the traditional character of Northumbrian baronial halls.'[127] The walls are 'battered' or inclined slightly and constructed of grey Clipsham limestone from Lincolnshire. Their surfaces are inscribed with the names of Newcastle's mayors and sheriffs dating back to 1216. Like the inscription at the base of the tower, these were exquisitely cut by David Dewey, giving the walls a unique texture. Enclosing the chamber, the ceiling is made of Abura timber from central Africa, with recessed panels of red hide. The timbers are enriched with the armorial bearings of the Companies of Freeman, Newcastle's medieval guilds.

A dais stands at one end of the hall, echoing the raised platform upon which barons would have dined in times past. In fact, the dais is an ingenious platform hoist that can descend 30 feet below the floor, allowing furniture to be moved in and out of the hall. During banquets, food is served through arches with

Banqueting hall. (Image © Newcastle City Council)

retractable cast-aluminium grills by Geoffrey Clarke. Backed with orange fabric, these resemble roaring fireplaces when illuminated, again evoking the atmosphere of medieval dining halls.

A lavish purple carpet covers the floor. Like equally colourful carpets throughout the building, this is decorated with castle and seahorse motifs, overlaid in spiralling patterns to produce an almost psychedelic effect reflecting the wider design culture of the 1960s. Cleverly, the central section of the carpet can be removed to expose a sprung dance floor of African Missanda hardwood.

Castles were often furnished with tapestries to relieve the stonework. The banqueting hall features a tapestry by the important post-war British painter John Piper (1903–92), who is best known for his kaleidoscopic stained-glass window at Coventry Cathedral. Made by French weavers at Aubusson, the tapestry is abstract in conception but based on the natural minerals and fauna of Northumberland.

Ascending to the first floor, the lobby leading to the council chamber is floored with Verde Patricia, a deep green marble from Italy, and boasts a ceiling of maple wood. Encased in thick walls, the council chamber feels secretive and impregnable, but there are galleries for the press and the public to observe council proceedings. Panels of Cedar of Lebanon unify the chamber, brilliantly designed with abstract sculptural forms that act as sound baffles to reduce echoes. Similarly, a ceiling of acoustic plaster sweeps up to a central oculus that admits natural light, recalling the Roman Pantheon.

As a crucible of local government, the chamber contains seating for Newcastle's councillors. The chairs were designed by the talented Danish furniture maker Arne Vodder (1926–2002) and executed in Avodire or 'African Satinwood' and Agba from the rainforests of West Africa. The chairs feature electronic voting panels, reflecting the Space Age design of the 1960s.

Council chamber. (Image
© Newcastle City Council)

The focal point of the chamber is the Lord Mayor's dais, which is made of Rio Rosewood from Brazil, a material favoured by Danish modern furniture makers in this period. A floor of Swedish marble was provided for sound reflection. Elsewhere, the floor is lined with a green ilex carpet by Wilton, a renowned manufacturer founded in 1741.

The civic centre houses seven committee rooms named after 'famous sons of the city'.[128] In each case, the walls are lined in coloured silk and 'Sculpturewood' panelling of Formosa and American black walnut. These spaces too are graced with furniture by Vodder, achieving the aesthetic harmony associated with Scandinavian modernism.

Originally, the most public space in the complex was the rates hall, where members of the public would pay their council bills. According to the architect, 'The impression gained on entering the hall is one of spaciousness and elegant proportions, together with fine detailing and selection of materials.'[129] The floor is lined with Fior di Pesco marble, from the Italian for 'peach tree', as well as Arabescato Nuova and Perlato Isernia. A large panel of Portoro marble from northern Italy acted as a backdrop to the counter, black but riven with gold veins. The counter itself was a fine example of timber craftsmanship in American black walnut. The ceiling was finished in acoustic plaster with a wave-form undulation to impart a sense of movement. At either end of the hall, abstract glass murals were created by Victor Pasmore, Master of Painting at King's College. Pasmore is perhaps best known for creating the equally uncompromising Apollo Pavilion (1963–69) at Peterlee New Town.

Committee room. (Image © Newcastle City Council)

Newcastle Civic Centre is an exceptional building, finished to the highest possible standard. A controversial £45-million programme of alterations was carried out in 2019 to designs by FaulknerBrowns. Council services were redistributed to promote greater operational efficiency and accommodation for HM Courts and Tribunal Service was created in the former rates hall, generating income for the city council. Nevertheless, the building remains a shining example of what modernist architecture can achieve when allied with political will and executed with consummate craftsmanship.

## Sunderland Civic Centre

After the Second World War, Sunderland Town Hall was deemed unfit for purpose. In 1964, Sunderland County Borough commissioned Sir Basil Spence to design a new civic centre on the rocky outcrop known as Building Hill. The demolition of the old town hall in 1971 remains controversial to this day.

Spence was born in Bombay and educated in India and Scotland. In 1950, he won the competition to design the new cathedral for Coventry, after the medieval building was destroyed by wartime bombing. This important commission, symbolic of Britain's post-war recovery, established him as a leading modernist architect. In 1964, the practice was reorganised, with the main office being renamed 'Sir Basil Spence OM RA', and the second office 'Spence, Bonnington & Collins'. It was this second office that was appointed to design Sunderland

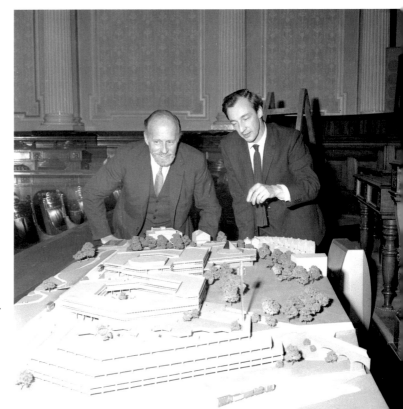

Spence and Bonnington inspecting a model of Sunderland Civic Centre. (Image © Sunderland Antiquarian Society)

Civic Centre, just before Spence departed for New Zealand to advise on its new parliament buildings. In his absence, John S. Bonnington was the project architect.

'Jack' Bonnington studied at Durham University and gained experience on town planning projects in the USA. With reference to Sunderland Civic Centre, he said 'I have always wanted to design a building of consequence in the North East.'[130] The Northern Architectural Association objected to building on the site, but construction started in January 1968 and was completed at a cost of £3,359,000. The design would have been more elaborate, but the Ministry of Housing & Local Government took exception to the proposed banqueting and reception halls and insisted on their omission to reduce the cost.

While Newcastle Civic Centre seemed old fashioned when opened in 1968, Sunderland Civic Centre, opened only two years later, was far more contemporary. The design consisted of two hexagonal rings, connected by a four-storey core. Each provided accommodation for administrative employees and had a landscaped courtyard at the centre. A polygonal civic suite, housing the council chamber, projected to the south, overlooking a townscape of Victorian terraced housing.

The building's angular profile had a strong horizontal emphasis, echoing the natural rock strata of Building Hill and giving it the character of a geological formation rather than an architectural monument. By following the contours of the site, the design minimised the need for expensive excavation and responded to the topography in the manner advocated by the great American architect Frank Lloyd Wright. As Bonnington explained, 'It appeared almost a natural solution to form a series of terraces, one leading to another, and follow the same pattern in the building itself with one floor retreating from the previous level.'[131] Linking the terraces, a series of artfully designed steps and ramps cascaded down to street

Sunderland Civic Centre. (Image © Peace Drone)

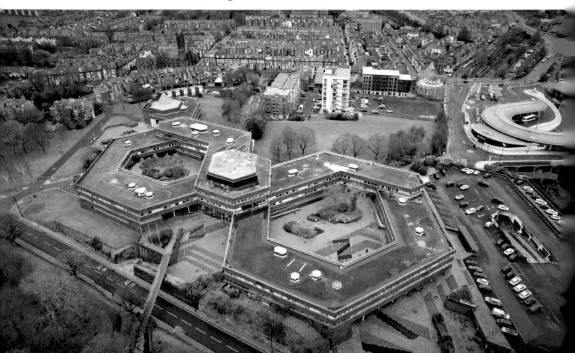

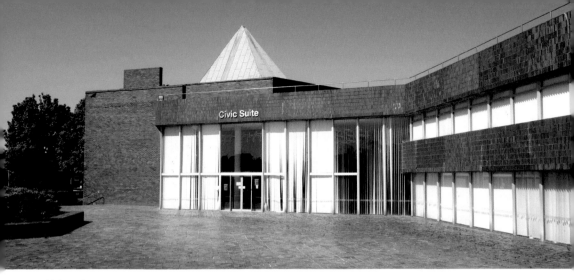

Civic suite.

level, heated to prevent freezing in winter. Polished metal handrails provided sparkling highlights to the bold geometry. A footbridge connected the building to Mowbray Park, further integrating it with the landscape.

In contrast to Newcastle Civic Centre, Sunderland adopted a modest material palette of brindled engineering bricks and tiles, all with a purplish sheen. The bricks were chosen to be more durable than concrete and were installed in pre-cast soldier courses (i.e. they were laid vertically). The same materials were used internally, creating a clear synergy between exterior and interior. In this respect, the design was probably influenced by Säynätsalo Town Hall (1949–51) by the renowned Finnish architect Alvar Aalto.

Southern courtyard.

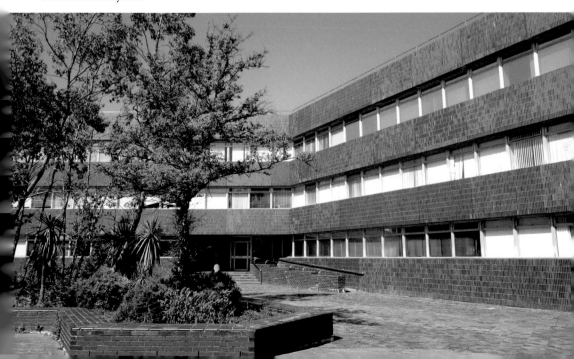

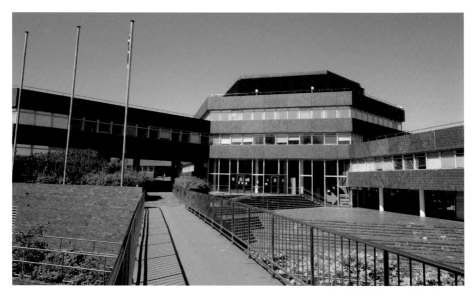

Administrative core.

The traditional town-hall plan placed the council chamber at the centre. Departing from this model, Sunderland Civic Centre was planned with the public enquiry desk at its central point, making the operations of local government more accessible to the public. Bonnington explained that the building was designed to create a continuous flow from one space to the next. The 120° angles arising from the hexagonal plan had the effect of opening up the corridors, making journeys around the building seem more direct. The hexagonal blocks were supported by powerful concrete columns, which allowed the non-loadbearing walls to be reconfigured if necessary.

The entrance hall of the civic suite was distinguished by an innovative chandelier, an asymmetrical lattice of hexagons formed from polished metallic tubes. Bonnington also designed a chained curtain for the glass walls. Both of these elements were inspired by features designed for Philip Johnson's Four Seasons restaurant in New York (1959), located within Mies van der Rohe's famous Seagram Building.

Beyond lay the superb council chamber, a hexagonal sanctum lined with brick and enclosed by a ceiling of Columbian pine, rising to a skylit apex. The play of natural light across walls of dark brick recalled the work of Eero Saarinen, particularly his MIT Chapel (1955). Like its counterpart in Newcastle, the chamber featured a state-of-the-art electronic voting system.

The civic centre was built by John Laing Construction of Newcastle, with steelwork by Ridghouse of Darlington. Ove Arup & Partners acted as structural consultants. Samuel Tyzack of Sunderland produced precast concrete mullions, tile-faced cladding panels and spandrel steps. The brindled clay paving and wall tiling was provided by Commercial Marble and Tiles of Newcastle, A. Andrews & Sons of Leeds and Hawkins Tiles of Cannock in Staffordshire. Internally, the basic

*Above*: Entrance to the council chamber.

*Right*: Council chamber. (Image © Historic England Archive)

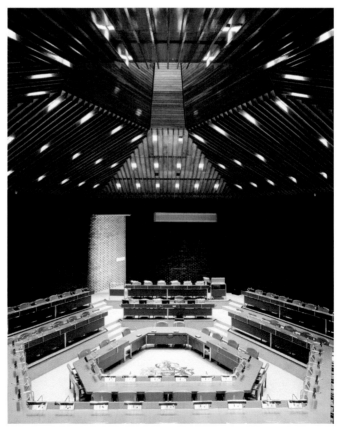

office furniture was supplied by Ryman Conran, together with 80,000 cubic feet of storage units by Mann Egerton of Norwich. It was reported that Spence designed much of the furniture himself, some of it repeating the hexagonal geometry of the superstructure. His furniture proved so successful that it was taken up by an office equipment manufacturer to market internationally.[132]

Elements of the design were echoed in Bonnington's town hall for Kensington (1972–76), another geometric composition in brick. The building received a gold award from the Royal Institute of British Architects for the way it responded to its landscape, while the Civic Trust called it 'A marvellous building which functions exactly as a town hall and civic centre should.'[133] The *Newcastle Journal* hailed it as a 'restrained, but beautifully designed and detailed building which every Sunderland ratepayer should be proud to have as a focus of civic life in his town.'[134] The building also won the Duke of Edinburgh's Design Prize in 1973, although when Deryk Clarke of the Design Council visited to set up the ceremony, he broke his nose by walking into the glass doors. 'Their design was a bit too modern for him', said a spokesman.[135]

With its distinctive double-hexagon design, Sunderland Civic Centre was an important late example of modernist architecture. The building embodied a democratic ideal of local government, but it was generally unpopular with Sunderland residents due to its abstract design and the fact that it replaced the much-loved town hall. In its last decades, the fabric was allowed to deteriorate. Sunderland Council claimed that the centre was too expensive to maintain and authorised the construction of a new City Hall on the former site of the Vaux Brewery. Commenced in 2019, this was designed by FaulknerBrowns. The civic centre was demolished in 2022, at great environmental cost, and its site was designated for housing.

## Darlington Town Hall

A new town hall for Darlington was conceived in 1964 to consolidate various council offices dispersed throughout the town. A civic quarter was established in the Feethams area on a site occupied by the Lead Yard bus station. While most civic buildings of the period were designated as 'civic centres', Darlington retained the traditional name of 'town hall', even though it adopted an inherently modern design.

The impetus came from a scheme devised by Borough Architect Eric Tornbohm. The result was a brutalist building designed in collaboration with the internationally important North-East firm of Williamson, Faulkner Brown & Partners. This practice was founded by Harry Faulkner-Brown (1920–2008), who served as a sapper or combat engineer during the Second World War. After working as an architect in Canada, he returned to Britain and entered practice with three partners in 1962. The firm achieved its first success with its striking design for Jesmond Library in Newcastle (1962–63), a modernist rotunda in steel and glass.

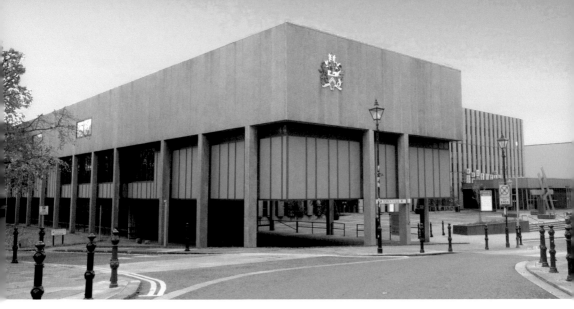

Darlington Town Hall.

Like Newcastle Civic Centre, Darlington Town Hall (1967–70) was conceived as an asymmetrical composition of distinct volumes, each articulating its separate function. Rising above a level concourse is a broad concrete block, with a similar range projecting at the rear. The façade is a uniform grid of dark, tinted windows and vertical panels of grey aggregate, rather Orwellian in effect. The abstraction of the main volume is tempered by the human scale of the glass-walled rates hall that shelters at its base.

The council chamber is housed within a longitudinal volume perpendicular to the main block. This powerful concrete edifice is raised on *pilotis* that descend from its upper storey. Below is an additional floor, clad in aluminium. This composition of suspended masses recalls Denys Lasdun's design for the Royal College of Physicians in London (1964). With its abstract assembly of concrete forms, the building is a cogent example of brutalism, a controversial architectural style much influenced by the late work of Le Corbusier. Coined by the Swedish architect Hans Asplund, the term was popularised by critic Reyner Banham, partly in reference to Le Corbusier's phrase *béton brut* (raw concrete).

The ceremonial entrance hall made lavish use of white marble and glass, recalling Newcastle Civic Centre and, ultimately, the rich materiality of Mies van der Rohe's work. A grand staircase led to the council chamber, a minimalist interior lined with vertical strips of elm wood and furnished with Space Age chairs in leather and rosewood, embossed with the town's coat of arms. These were designed by renowned British furniture maker Peter Hoyte in 1969.

A constructivist sculpture of riveted stainless-steel beams was erected outside the town hall in 1970. Commissioned by Darlington Lions Club, this was designed by John Hoskin (1921–90). Officially named *The Spirit of New Darlington*, the structure is better known as *Resurgence* and was intended to represent Darlington's recovery after the decline of its pioneering railway industry. The cost of £7,000 was met by the Lions Club, the Arts Council and the Northern Art Association.[136]

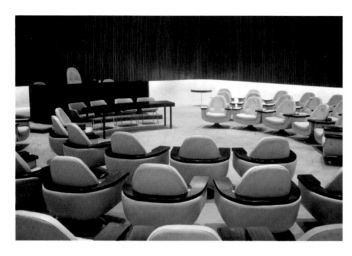

Council
chamber. (Image
© FaulknerBrowns
Architects)

The town hall remains the principal seat of government for Darlington, but additional accommodation for the borough council was erected south-west of the main building in 2020. At the same time, the town hall was subjected to a full 'strip-out' of the interior by Space Design & Construction, compromising the modernist *Gesamtkunstwerk* achieved by the original architects.

## Chester-le-Street Civic Centre

The historic market town of Chester-le-Street lies north of the River Wear, nestled in a vale between Waldridge Fell and the limestone plateau that stretches to the sea. The settlement originated as the Roman fort of Concangis, built in the second century. The town's modern name derives from the Old English 'ceaster', meaning 'Roman fortification', and 'street', referring to a paved Roman road that ran through the town, where Front Street now lies. The body of St Cuthbert rested at Chester-le-Street for 112 years before being conveyed to Durham, where the majestic Romanesque cathedral was built over his shrine.

Coalmining in the district began in the late seventeenth century, using the rivers for transportation, and Chester-le-Street became a commercial centre. By the 1970s, the town's governing body was housed in four buildings along Front Street. To consolidate the departments, a unified civic centre was built in 1979–82 at a cost of £3 million. The futuristic building was designed by Faulkner-Brown Hendy Watkinson Stonor and was the first major work by Neil Taylor, the firm's longest-serving partner. The design was realised by Wimpey Construction.

The 1974 Local Government Act marked a move towards a more efficient and accountable system of local government. With an established Labour majority in the council, the new civic centre was conceived as a model of democratic openness. Its design was a deliberate break from the Victorian tradition of town halls as

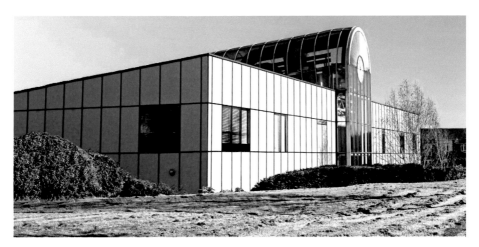

Chester-le-Street Civic Centre.

imposing civic temples. The result was a unique structure, unprecedented among the region's civic buildings.

Introducing the high-tech style of architecture to the North East, Chester-le-Street Civic Centre was a sleek assembly of silver planes enclosing a multicoloured riot of structural and mechanical components. Emerging in the late 1970s, the high-tech movement responded to the fragmentation of modernism by embracing technology and engineering as a basis for architecture. Echoing metropolitan examples such as the Centre Pompidou in Paris (1971–77) and Lloyd's of London (1978–86), the civic centre displayed an exaggerated mechanical aesthetic, exposing its framework and service ducts, though it was designed on a more human scale than these technocratic fantasies. In this specific context, the mechanistic iconography suggested nostalgia for the industries that had departed the North East.

Poor ground conditions necessitated a lightweight building. The centre was system-built using a steel portal frame with lattice trusses. Thanks to this efficient system, construction was completed in only twenty-three months. The framework was clad in a silver skin of Alucobond panels made by Booth-Muirie of Glasgow, consisting of aluminium and polyethylene layers. To match the walls, the roof was clad in silver PVF2-coated steel. The ceilings were of steel louvres made by Grada-Netaline and provided good light and ventilation. Landscaping by H. J. Lowe softened the hard-edged architecture, helping to blend this somewhat alien structure into its setting. Silver birch trees were the natural choice to complement the building's glistening façade.

To maximise accessibility, the building was sited with its main axis on an existing public footpath leading from the town centre. The design incorporated lessons learned from the architects' earlier town hall at Darlington. Instead of separate blocks for councillors and officers, all departments were unified under the sloping plane of a single, monopitch roof.

Egalitarian in conception, the centre was designed without the traditional symbols of 'civitas'. The only indications of its civic function were the clock face

and flagpoles outside and there were no overt references to the town's past, as the architects considered such gestures a throwback. As a result, some critics claimed it resembled a corporate headquarters or industrial plant more than a civic building and local residents nicknamed it 'Mission Control'.

To create a welcoming experience, a mall ran the length of the building, placed off-centre to avoid symmetry. The space was lit by a transparent plastic barrel vault, a popular vernacular form more familiar from retail complexes. Lloyds of London used similar barrel-vaulted skylights, as did Selby Civic Centre (1977), a building that was visited by Chester-le-Street's client and design team. Enquiry desks and access to the various council departments were located along the length of the mall to make the internal workings of the civic centre accessible. The message was that citizens, not councillors, were at the heart of local government.

In planning the interior, the architects exploited the gentle slope of the site to provide distinct spatial zones: public amenities and open-plan offices on the ground floor and councillors' rooms on a mezzanine, all in full view of the public. Running perpendicular to the mall was an amenity zone comprising a restaurant and waiting area. This space was treated as a conservatory, with light flooding through the roof. Festooned with vegetation and carpeted in green Astroturf, the space exemplified the 'jungle aesthetic' favoured by consumer emporia and leisure centres in the 1980s. The resulting cruciform plan, sloping axis and aqua-blue rubber flooring recalled the archetypal layout of Islamic gardens, amusingly suggesting an earthly paradise achieved through the miracle of administrative socialism.

The rest of the ground floor was a *bürolandschaft* or 'office-landscape'. This was an office-planning system developed in Germany in the 1950s by Eberhard and

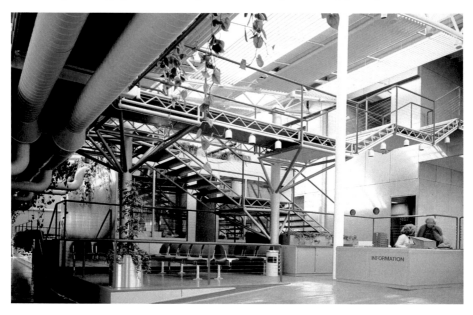

Enquiry desk within the public mall. (Image © Richard Bryant)

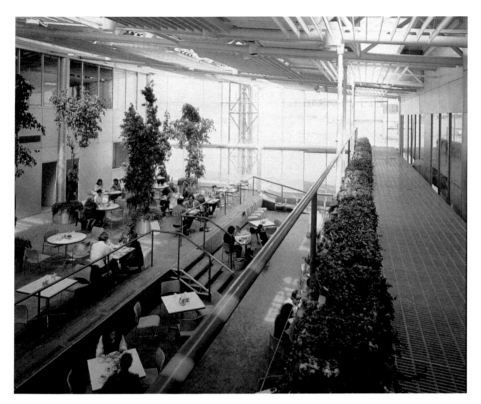

Public amenity zone. (Image © Richard Bryant)

Wolfgang Schnelle, based on offices devised in the USA in the 1940s. The system encouraged all staff to work together on one open-plan floor to create a non-hierarchical environment that fostered collaboration. Specifically, Chester-le-Street's office spaces were modelled on the architects' own offices at Killingworth (1972).

The council chamber, the traditional focus of civic buildings, was modestly inconspicuous. Only the coat of arms on the wall and the circular seating plan, signifying democracy, distinguished it from the other rooms. A futurist colour palette was achieved with a grey carpet, silver walls and chairs in pink fabric designed by R. Peacock.

Chester-le-Street Civic Centre was a skilful attempt to embody an ethos of democratic local government. However, council services were transferred to other buildings in 2013 and the centre was demolished the following year. Reflecting on his innovative design, the best example of high-tech architecture in the region, project architect Neil Taylor said 'The significance of the design was that it established a totally new relationship between elected members, Council officers and the public. It not only allowed simple and easy access, but also made the people who worked in the building visually accountable.'[137] This remains a worthy ambition for civic architecture in the twenty-first century, reminding elected officials that their duty is to uphold the ideals of democracy and serve the public with integrity.

*Left*: Bürolandschaft offices. (Image © Richard Bryant)

*Below*: Council chamber. (Image © Richard Bryant)

# Notes

1. *Building News*, 24 January 1896, pp. 117–118.
2. *Newcastle Courant*, 31 March 1865, p. 5.
3. An open pediment is an ornamental gable from which the base has been removed.
4. Unfortunately, Eastbury was destroyed in 1775.
5. However, there appear to be no newspaper reports of such a fire.
6. *Morpeth Herald*, 1 October 1870, p.5. Johnson's façade is said to be 1 foot taller than the original, due to the use of thicker mortar beds.
7. *Morpeth Herald*, 3 April 1869, p. 5.
8. *Morpeth Herald*, 1 October 1870, p. 5.
9. Unspecified source quoted at http://www.thisisstockton.co.uk/history/stockton-town-hall-history.asp
10. *Building News*, 24 January 1896, p. 111.
11. Unspecified source quoted at https://freemenofberwick.org.uk/town-hall/
12. Unspecified source quoted in Brenchley, 1997.
13. Pevsner (2002) suggests that Dodds merely tinkered with the Worralls' plan, but Brenchley (1997) is more convincing in giving most of the credit to Dodds.
14. *Newcastle Chronicle*, 3 August 1870, p.5.
15. Ibid., p. 5.
16. Ibid., p. 5.
17. *Northern Echo*, 13 April 1878, p. 3.
18. *The Era*, 17 August 1845, p. 8.
19. Ibid., p. 8.
20. *The Era*, 16 February 1845, p. 8.
21. *Durham Chronicle*, 18 November 1853, p. 1.
22. *Durham Chronicle*, 27 April 1849, p. 8.
23. Ibid., p. 8.
24. *Durham Chronicle*, 7 February 1851, p. 1.
25. *Durham Chronicle*, 18 November 1853, p. 1.
26. This quotation comes from a cartouche below the coat of arms.
27. *Newcastle Courant*, 3 September 1858, p. 5.
28. Faulkner, T. E. (ed.), *Northumbrian Panorama*, p. 130.
29. *Builder*, 11 September 1858, p. 61.
30. *Newcastle Courant*, 3 September 1858, p. 5.

31. Ibid., p. 5.
32. Ibid., p. 5.
33. Ibid., p. 5.
34. Ibid., p. 5.
35. Ibid., p. 5.
36. Ibid., p. 5.
37. *Builder*, 8 October 1898, p. 307.
38. *Building News*, 29 July 1881, p. 133.
39. Report from 1965 quoted in *Newcastle Chronicle*, 22 May 2014.
40. www.bishopaucklandtownhall.org.uk.
41. *Newcastle Courant*, 18 April 1862, p. 1.
42. *Builder*, 7 April 1860, p. 216.
43. *Builder*, 11 July 1857, p. 383.
44. *Builder*, 7 April 1860, p. 216.
45. Ibid., p. 216.
46. *Building News*, 17 February 1860, p. 120.
47. Ibid., p. 120, and *Newcastle Daily Chronicle*, 9 February 1860, p. 2.
48. *Teesdale Mercury*, 3 December 1862, p. 4.
49. *Building News*, 7 November 1862, p. 363.
50. Ibid., p. 363.
51. *Durham Chronicle*, 30 January 1863, p. 7.
52. Cunningham and Waterhouse, *Alfred Waterhouse, 1830–1905: Biography of a Practice*, 1992, p. 185.
53. Ibid., p. 165.
54. *North Eastern Weekly Gazette*, 29 August 1891, p. 5.
55. *Yorkshire Post*, 8 July 1927, p. 12, and 31 January 1928, p. 12.
56. *Newcastle Courant*, 14 September 1866, p. 5.
57. *Newcastle Courant*, 31 March 1865, p. 5.
58. Ibid., p. 5.
59. *Newcastle Courant*, 14 September 1866, p. 5.
60. *Newcastle Journal*, 14 September 1866, p. 3.
61. *Builder*, 4 July 1863, p. 469.
62. Ibid., p. 471.
63. *Building News*, 8 March 1867, p. vii.
64. *Builder*, 5 October 1867, p. 736.
65. *Builder*, 13 July 1867, p. 514.
66. *South Durham and Cleveland Mercury*, 15 September 1877, p. 6.
67. *Building News*, 2 May 1879, p. 468.
68. *Builder*, 29 November 1879, p. 1,321.
69. *Northern Weekly Gazette*, 13 September 1879, p. 4.
70. *Northern Weekly Gazette*, 15 November 1879, p. 8.
71. Ibid., p. 8.
72. *Cleveland Standard*, 12 November 1948, p. 1.

73. *Building News*, 13 January 1883, p. 42.
74. Unspecified source quoted at https://www.middlesbroughtownhall.co.uk/.
75. *Builder*, 30 July 1887, p. 190.
76. *Architect*, 20 June 1874, p. 348.
77. *Sunderland Daily Echo*, 29 April 1886, p. 4.
78. *Building News*, 28 February 1890, p. 306.
79. *Builder*, 21 May 1887, p. 763.
80. *Builder*, 14 June 1890, p. 45.
81. *Monthly Chronicle of North Country Lore and Legend*, January 1891, p. 16.
82. *Building News*, 29 January 1904, p. 163, and 19 February 1904, p. 271.
83. *Newcastle Courant*, 24 June 1887, p. 5.
84. *Newcastle Chronicle*, 20 June 1887, p. 8.
85. *Newcastle Courant*, 24 June 1887, p. 5.
86. *Newcastle Weekly Chronicle*, 2 July 1887, p. 5.
87. *Newcastle Daily Chronicle*, 17 June 1887, p. 4.
88. *Northern Echo*, 6 October 1892, p. 3.
89. *Middlesbrough Daily Gazette*, 26 May 1892, p. 3.
90. *Northern Echo*, 6 October 1892, p. 3.
91. Pevsner, *The Buildings of England: Yorkshire, The North Riding*, 2002.
92. *Builder*, 1 November 1862, p. 778.
93. *Daily Gazette*, 6 May 1878, p. 2.
94. *Building News*, 6 December 1889, p. 791.
95. *Builder*, 9 October 1897, p. 290.
96. Ibid., p. 290.
97. *Shields Daily Gazette*, 26 April 1891, p. 3.
98. *Shields Daily Gazette*, 26 April 1901, p. 3.
99. *Shields Daily Gazette*, 3 May 1902, p. 1.
100. *Shields Daily Gazette*, 26 April 1901, p. 3.
101. *Sunderland Daily Echo*, 16 June 1904, p. 5.
102. *Building News*, 1 January 1904, p. 1.
103. See Cunningham, *Victorian and Edwardian Town Halls*, 1981, p. 199, and Pevsner, *Durham*, 2021, p.519.
104. *Morpeth Herald*, 21 January 1905, p. 7.
105. *Building News*, 17 September 1869, p. 230.
106. *Builder*, 11 September 1869, p. 733.
107. *Building News*, 17 September 1869, p. 230.
108. *Building News*, 24 September 1869, p. 246.
109. Ibid., p. 246.
110. *Shields Daily News*, 5 April 1905, p. 3.
111. *Yorkshire Post and Leeds Intelligencer*, 12 April 1905, p. 8.
112. *Shields Daily News*, 7 February 1905, p. 3.
113. *Labour Leader*, 29 January 1909, p. 78.

114. *Newcastle Daily Chronicle*, 2 January 1909, p. 11.
115. *Newcastle Evening Chronicle*, 2 March 1909, p. 6.
116. Ibid., p. 6.
117. *Newcastle Daily Chronicle*, 10 March 1909, p. 5.
118. *Shields Daily News*, 7 February 1905, p. 3.
119. *Jarrow Express*, 8 July 1904, p. 8, and 12 August 1904, p. 5.
120. *Newcastle Daily Chronicle*, 10 June 1904, p. 6.
121. *Newcastle Daily Chronicle*, 19 June 1907, p. 11.
122. *Jarrow Express*, 18 September 1908, p. 5.
123. *Jarrow Express*, 13 November 1908, p. 5.
124. Newcastle City Council, *Ceremony of Acceptance of the First Stage of the Civic Centre*, 1963, n. p.
125. Ibid.
126. Newcastle City Council, *Civic Centre: Newcastle upon Tyne*, 1968, n. p.
127. Ibid.
128. Ibid.
129. Newcastle City Council, *Ceremony of Acceptance of the First Stage of the Civic Centre*, 1963, n. p.
130. *Newcastle Journal*, 5 November 1979, p. 4.
131. *Northern Architect*, 1975.
132. *Newcastle Evening Chronicle*, 1 January 1970, p. 7.
133. *Newcastle Journal*, 5 March 1973, p. 5.
134. Ibid., p. 5.
135. *Daily Mirror*, 31 May 1973, p. 15.
136. *Newcastle Journal*, 21 May 1970, p. 7.
137. Neil Taylor quoted in *Architects' Journal*, 3 November 2014.

# Bibliography

Brenchley, David, *A Place by Itself: Berwick-upon-Tweed in the Eighteenth Century* (Berwick-upon-Tweed: Berwick-upon-Tweed Civic Society, 1997).

Cunningham, Colin, and Waterhouse, Prudence, *Alfred Waterhouse, 1830–1905: Biography of a Practice* (Oxford: Clarendon, 1992).

Cunningham, Colin, *Victorian and Edwardian Town Halls* (London: Routledge, 1981).

Downes, Kerry, *Vanbrugh* (London: Zwemmer, 1977).

Faulkner, Thomas, *et al.*, *Newcastle and Gateshead: Architecture and Heritage* (Newcastle: Tyne Bridge Publishing, 2014).

Faulkner, Thomas (ed.), *Northumbrian Panorama: Studies in the History and Culture of North-East England* (London: Octavian Press, 1996).

Felstead, Alison, *et al.*, *Directory of British Architects, 1834–1900* (London, Mansell Publishing, 1993).

McCombie, Grace, *Newcastle and Gateshead* (New Haven: Yale University Press, 2009).

Newcastle City Council, *Ceremony of Acceptance of the First Stage of the Civic Centre* (Newcastle: Newcastle City Council, 1963).

Newcastle City Council, *Civic Centre: Newcastle upon Tyne* (Newcastle: Newcastle City Council, 1968).

Pevsner, Nikolaus, *et al.*, *The Buildings of England: County Durham* (New Haven: Yale University Press, 2021).

Pevsner, Nikolaus, *et al.*, *The Buildings of England: Northumberland* (New Haven: Yale University Press, 2002).

Pevsner, Nikolaus, *et al.*, *The Buildings of England: Yorkshire, The North Riding* (New Haven: Yale University Press, 2002).

Reeves, Dawn, and Collingham, Fran, *Town Hall: Buildings, People and Power* (Shared Press, 2018).

Ridgway, Christopher, and Williams, Robert, *Sir John Vanbrugh and Landscape Architecture in Baroque England, 1690–1730* (Stroud: Sutton, 2000).

Roberts, Martin, *Durham: 1000 Years of History* (Stroud: Tempus, 2003).

Walker, Jim, *Berwick-upon-Tweed* (Stroud: Tempus, 2001).

Woodhouse, Robert, *Stockton Past* (Bognor Regis, Phillimore, 1994).

# Index